PHOTO HACKS

An Hachette UK Company
www.hachette.co.uk

First published in Great Britain in 2019 by
Ilex, an imprint of Octopus Publishing Group Ltd
Carmelite House
50 Victoria Embankment
London, EC4Y 0DZ
www.octopusbooks.co.uk

Distributed in the US by
Hachette Book Group
1290 Avenue of the Americas
4th and 5th Floors
New York, NY 10104

Distributed in Canada by
Canadian Manda Group
664 Annette St.
Toronto, Ontario, Canada M6S 2C8

Publisher: Alison Starling
Commissioner: Frank Gallaugher
Managing Editor: Rachel Silverlight
Editor: Jenny Dye
Art Director: Ben Gardiner
Design: JC Lanaway
Production Controller: Grace O'Byrne

ISBN 978-1-78157-566-6

A CIP catalogue record for this book
is available from the British Library

Printed and bound in China

10 9 8 7 6 5 4 3 2 1

Simple Solutions for Better Photos

PHOTO HACKS

IMOGEN DYER & MARK WILKINSON

ilex

CONTENTS

6 Introduction

DIY PHOTO GEAR

10 Window light box

12 Easy soft-focus shots

14 Pop-up diffuser & reflector

16 Sunglass filters

18 Budget reflector

20 Shoot-through reflector

22 Yoghurt-carton lens hood

24 DIY light box

26 Jumbo diffuser

30 iPad light panel

32 Budget beauty dish

34 Candy-wrapper filters

36 Portable seamless background

38 Camera rain bag

40 Reflective-card hack for product photography

42 Bean-bag tripod

44 String stabiliser

SHOOTING TRICKS

48 Match film burn

50 Shoot in public

54 Finding beautiful light

58 Laptop backdrop

60 Get closer

62 DIY lens flare

64 Try a prism

66 Go psychedelic

68 Crystal drop flare

70 Rule of Thirds

72 Choosing a format

76 Freelensing

78 Convert to black and white

82 Obscured foregrounds

84 Coordinate your colours

86 Postive & negative space

88 Mirror, mirror

90 Golden hour

92 Create a diptych or triptych

94 Take on a photo challenge

CAMERAS

98 Pinhole camera

102 Through the viewfinder

106 Camera-phone macro lens

108 Macro tube

112 Sunprint

114 35mm disposable cameras

116 Experimental film

118 Vintage lenses

STUDIO SETUPS

122 Outdoor studio

124 Easy home studio

126 Vibrant paper backgrounds

128 Bedsheet backgrounds

WORKING WITH MODELS

132 Cheap but amazing props

134 No-cost locations

136 Get to the beach

138 Perfect poses

142 Index

144 About the authors &
 Acknowledgements

INTRODUCTION

The world of photography extends far beyond the humble camera. Photography can be enhanced using lighting, filters, tripods, editing equipment...the list is endless. However, building up a tool kit or even finding places to shoot can become difficult and expensive. With this book we aim to provide you with a manual of creative and money-saving ideas to help you boost your photography without breaking the bank.

Since beginning our work together, Mark and I have always focused on composition, presenting a theme or story and creating a cohesive and creative image; we have rarely delved into the technical side of the photography world. For many years we shot together using solely a Canon 550D and a 50mm lens, often using DIY tripods, clothes from boot fairs, pieces of card as backgrounds and always with some strong sticky tape on hand for a variety of background and costume malfunctions. Although Mark's camera-equipment collection has grown considerably since our first shoot in 2009 and we have now invested in several second-hand tripods, we have never stopped seeking out DIY photography projects and cheap or free props and locations, and sticky tape is still an essential part of our tool kit. This has become a trademark of the way we work, and since starting our YouTube channel, we have focused especially on low-budget ways to create beautiful results.

Mark and I have also always enjoyed the fun process of trying out photographic craft projects and sharing our findings with others. It seemed natural and fitting therefore to share the tricks that we have been using throughout our years together and to delve further into the world of photo hacks.

You'll find a variety of projects to help you produce amazing results with your photography. From classic hacks in 'DIY Photo Gear' to our tips on how to create amazing photos on a budget in 'Shooting tricks', 'Cameras' and 'Working with models' we hope there will be something in every section that helps and inspires.

Photo hacks turn 'I can't' into a creative 'I can'. We hope this book will provide problem-solving ideas and projects for when you feel like you can't achieve the photo you want because you don't have the equipment, location or setup. We also hope that it will inspire you to create photo hacks of your own!

DIY PHOTO GEAR

WINDOW LIGHT BOX

Using a light box is a great way to capture beautiful, clean photos. This piece of equipment creates a crisp, white background that allows items to pop and become the clear focal point of the image. However, professional light boxes can cost a significant amount. This photo hack outlines an easy and cost-effective way to create a light-box effect using paper and natural lighting.

COST: $$
DIFFICULTY:

MATERIALS:
- Plain white paper (A4 or A3)
- Clear sticky tape
- Window

A white background will trick your camera's meter. To avoid underexposure, set exposure compensation to +1/3 or +2/3.

1. Choose a window, preferably with a good source of natural light.

2. Place the object you would like to shoot in front of the window.

3. Hold the sheet of paper on the window behind the object and adjust until it forms a well-placed background.

4. Secure the paper onto the window with the sticky tape.

5. Set your camera to AV or A mode.

6. Adjust the exposure compensation to a plus (+) setting.

7. Focus on your subject.

This technique makes a beautifully lit shot, whether in colour or black and white.

EASY SOFT-FOCUS SHOTS

COST: $$$
DIFFICULTY: ▮▯▯

MATERIALS:
- Clear sandwich bag
- Elastic band (optional)

Create beautiful photographs with a hazy, soft focus simply by using a sandwich bag. By placing a torn sandwich bag around the lens, your subject can still be clearly in focus while the surrounding edges are covered in an ethereal blur. This creates a wonderful other-worldly effect, adding a romantic, soft and vintage feel to your photographs.

This plastic bag costs pennies yet imparts a high-end effect.

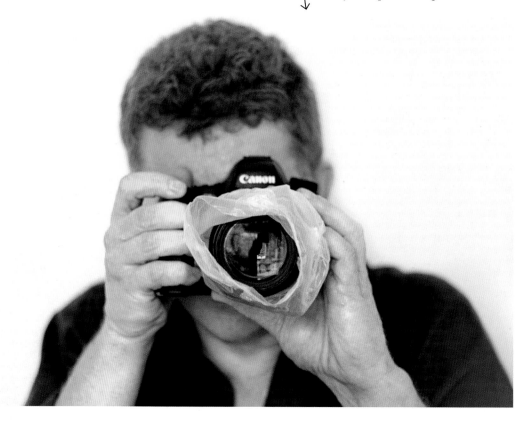

1. Tear a hole in the bottom of the sandwich bag.

2. Place the open end of the sandwich bag over the lens.

3. Arrange the torn hole around the lens, making sure that some of the crumpled plastic overlaps the front of the lens.

4. Looking through the viewfinder, rearrange the sandwich bag until you've achieved a soft blur around the edges, leaving a central hole to focus on the centre of your image.

5. Once you're pleased with the effects, secure the sandwich bag by placing an elastic band over it and the lens; or alternatively, hold in place using your hand.

← We created a soft, hazy light in the bottom of the photo by arranging the plastic bag over the lower half of the lens.

Experiment to discover how the placement of the bag changes the look of your images.

POP-UP DIFFUSER & REFLECTOR

Flash is a great way to add extra light to an image when needed, but pointing a flash directly at the subject can result in hard, flat light with harsh shadows. Diffusers and reflectors are modifiers that transform your light source into an indirect one. This simple adjustment creates a softer, more even light, which often produces much better results. Light modifiers cost good money, but they're easy to emulate using everyday materials.

COST: $$$
DIFFICULTY: ▮▯▯

DIFFUSER MATERIALS:
- White film cannister
- Knife
- Marker pen

REFLECTOR MATERIALS:
- Thin sheet of white card
- Scissors
- Camera with pop-up flash
- Adhesive tack

DIFFUSER:

When working outdoors or in a room with high ceilings, a light diffuser around the flash works to soften the light. This hack shows you how to create a budget light diffuser that can be placed over your flash so you are prepared for any setting.

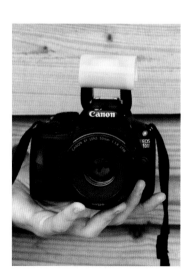

1. Take the lid off the film cannister and cut the bottom off.

2. Use a knife to slice the side of the cannister.

3. Place the curled piece of plastic over your pop-up flash as shown. Remove and trim the plastic if necessary for a better fit.

REFLECTOR:

This hack shows you how to make a cheap reflector using a piece of card that works incredibly well when shooting indoors with a flash. The light from the flash is channelled upwards, away from the subject, and bounces back down to create an even wash of light.

1. Cut a 9 by 5cm (3 ½ by 2in) rectangle.

2. Pop your flash up and hold the card in front of it. It should fit approximately as shown. Trim as needed.

3. Place the adhesive tack in the front of the flash bed as shown below.

4. Stick the card in, using the adhesive tack to hold it in place.

↑ Before using the homemade reflector, the flash creates a strong, harsh light.

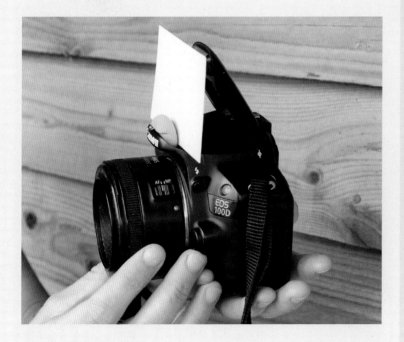

↑ With the use of our homemade reflector, the subject is well lit, but the light appears much softer and more even.

SUNGLASS FILTERS

COST: $$$
DIFFICULTY: ■□□

MATERIALS:
• Sunglasses

Coloured filters are often used in photography to balance out colour in an image. However, an alternative way to use these filters is to create a single colour hue over the whole image. This can be used to create a fun pop-art effect. Like a lot of photographic gear, these filters can be an expensive addition to your kit, but using lenses from sunglasses is a cheap and effective way to create a similar effect.

This hack might give a new lease of life to that old stash of sunglasses!

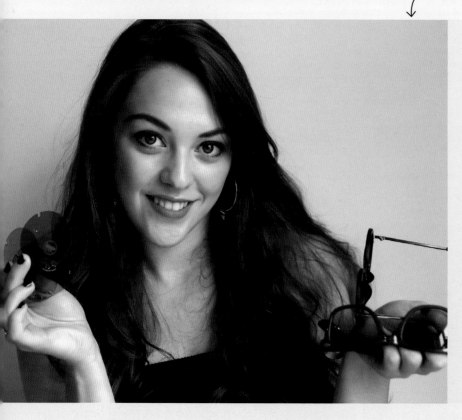

It is useful to look out for circular lenses as these will fit neatly over your lens. If you have bought cheap sunglasses to use as filters, you can even pop out the glass or plastic to hold directly over the lens.

Sunglasses often contain tinted lenses with a sepia or blue-green tone, and it's also possible to buy sunglasses with different coloured lenses. Some sunglasses also have a gradient in the glass which can produce a vignette effect.

↑ Red and blue lenses were used to add colour to these images.

1. Focus your camera on your subject.

2. Hold the sunglasses over the lens of your camera to create a subtle wash of colour over the image.

3. Experiment with the positioning of the lens, especially if you've taken it out of the glasses frame. Just partially covering the camera lens with the sunglasses lens can create an interesting hazy effect with a partial section of colour.

4. In post-production, you can pull up the saturation to create a bolder, more intense colour, or tame effects that seem too intense.

You can place the sunglasses lens partially over the camera lens to create a gradient of colour.

BUDGET REFLECTOR

We shared our flash reflector hack on page 15, and reflectors are one of the most useful additions to your photographic tool kit when working in natural light too. Sunlight and other bright ambient light sources tend to cause harsh, unflattering shadows. Natural light reflectors work by bouncing that light source onto the subject to even out contrast between light and shadow and illuminate the focus of your photograph.

In this image, a white polystyrene board is used to bounce light onto the model's face for a perfect portrait.

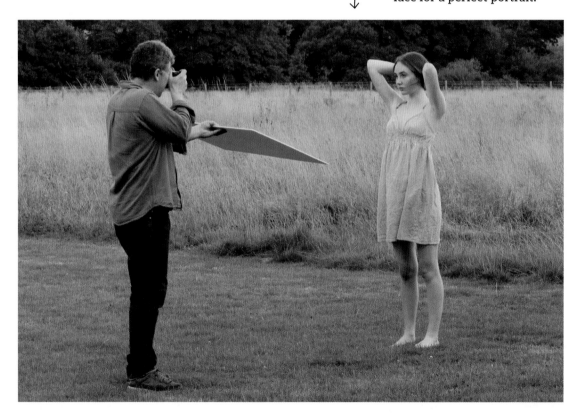

1. Cut your white card or polystyrene board to the size you require.

2. When taking your photos, use the reflector to bounce light onto the subject and illuminate areas that may be in shadow.

3. You can also use your reflector to create shade if the light source is too bright, by holding it between the subject and the light.

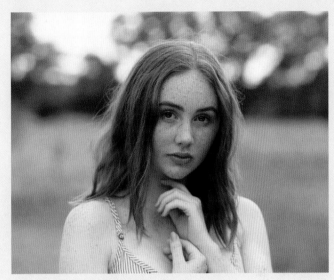

↑ Without the reflector

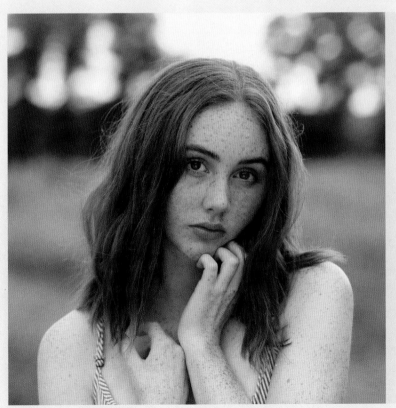

↑ With the reflector

A white reflector fills in shadows to even out illumination as shown here. For a more dramatic effect with darker shadows, you can cover one side of your card or board with black paper and use that side to diminish the light on your subject.

SHOOT-THROUGH REFLECTOR

Shooting through a reflector enables even softer light than the method from the previous hack. A reflector is effectively a light source, and the larger a light source in relation to the subject, the softer the light will be. Having your light source mounted on the camera not only eliminates the need for an assistant, but it also allows you to get your light source very close to the subject. This hack provides an easy and cheap alternative to buying a ring light (a flash that mounts around the lens shaft).

You can still use this hacked shoot-through reflector like a normal reflector – just watch out for shadow or light coming through the hole in the centre.

COST: $$$
DIFFICULTY: ▮▮▯

MATERIALS:
- Reflector
- Marker pen
- Scissors/knife
- Strong tape

We cut the hole in the reflector so it would sit right on the lens for support.

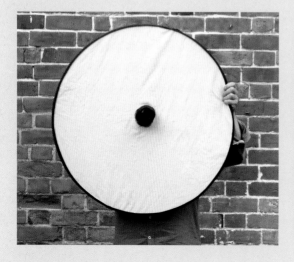

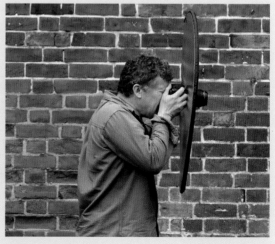

1. Position your camera lens in the middle of the reflector.

2. Draw around the lens with a marker pen.

3. Using scissors or a knife, cut the marked circle out of the middle of the reflector.

4. Stick strips of strong tape around the cut-out hole to reinforce it.

5. Place your camera lens through the reflector.

In post-production, try increasing the colour of key features such as eyes, lips or hair for more impact.

→ The shoot-through reflector achieves even light across the model's face, creating a beautifully lit portrait.

YOGHURT-CARTON LENS HOOD

COST: $$$

DIFFICULTY: ▮▮▯

MATERIALS:

- Large yoghurt carton – approx. 500g (15oz)
- Scissors
- Newspaper
- Black spray paint

When shooting in bright sunlight, your images may incur lens flare. Although this can sometimes be used to good effect, it can often ruin an otherwise strong photograph. Lens hoods are used to shade the bright sunlight off the lens so that you can get a clean, crisp, lens-flare-free photograph. However, like a lot of photography equipment, this can be an expensive investment. With this simple hack, you can make a cheap and effective lens hood.

Svelte, stylish and discreet. Go to a camera manufacturer's website, look at how much they charge for their lens hoods and laugh!

1. Empty and wash the yoghurt carton.

2. Remove the lid and any extra foil so you are left with just the plastic carton.

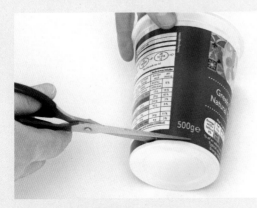

3. Using scissors, cut the bottom off the yoghurt carton.

4. Place the yoghurt carton over your lens. Trim the bottom of the carton as needed to accommodate the circumference of your lens.

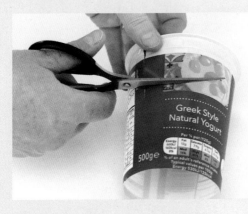

5. Measure the carton and trim the top so it is about 5cm (2in) longer than your lens.

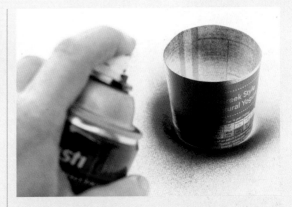

6. Lay out the newspaper and spray paint the inside and outside of the yoghurt carton. We suggest black as it will match your camera but you can use any colour you like.

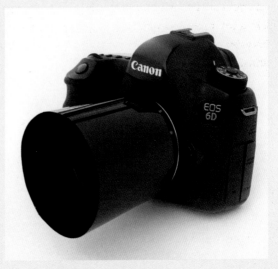

7. Place the painted yoghurt carton over your lens.

DIY LIGHT BOX

Light boxes are often used in product photography to create a clean seamless background, which allows the product to be the central focus of the image. This hack shows you how to create your own light box using cardboard and paper. The large sheet of white paper in the centre of the box will create an even background without distracting dividing sections, and the tracing paper or tissue paper will flood diffused, soft light onto your product.

COST: $$$

DIFFICULTY:

MATERIALS:

- Scissors
- Box cutter
- Cardboard box (big enough to place your products inside)
- Ruler
- Tracing paper or tissue paper
- Sticky tape
- Large sheet of white paper
- Three lamps

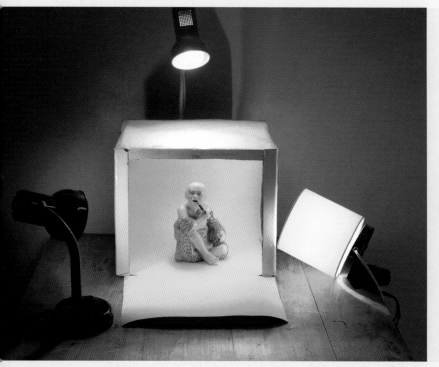

Artificial lights should all be roughly the same temperature (degrees Kelvin) to prevent white-balance issues in your images. Alternatively, you can try placing your light box near a bright source of natural light.

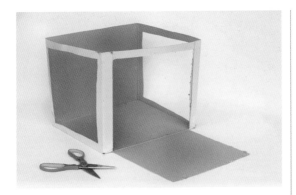

1. Using scissors or a box cutter, cut your box so that three sides are open and one has an extended flap which protrudes out from the front. This will create the opening into which you can place objects.

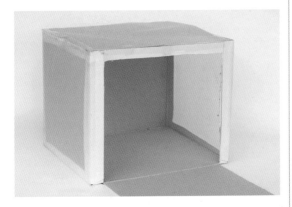

2. Cut three pieces of tracing or tissue paper to the size of the sides of your box and secure these over the two sides and top of your light box.

3. Bend your large sheet of white paper so that it covers the back of your light box and extends out of the front. This will create the background for your product.

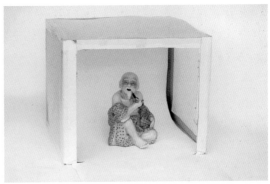

4. Place your product inside.

5. Set up three lamps around your light box – one pointing down onto the top of the box and two pointing into the sides.

↑ A light box softens the light falling on the subject and eliminates harsh shadows.

JUMBO DIFFUSER

Shooting in natural light produces beautiful results but it can be unpredictable. Strong sunlight can cause problems in a shoot, leaving a model squinting or casting harsh shadows across your subject. However, strong light doesn't have to spell disaster. This hack shows you how to make a collapsible, jumbo diffuser to use when working in harsh natural light.

COST: $$$
DIFFICULTY: ▮▮▮

MATERIALS:

- Tape measure
- Translucent white shower curtain
- Scissors
- Plastic pipe roughly 3cm (1in) in diameter
- Saw
- 4 right-angle corners for the pipe
- 2 T-pieces for the pipe
- Strong tape
- Velcro®

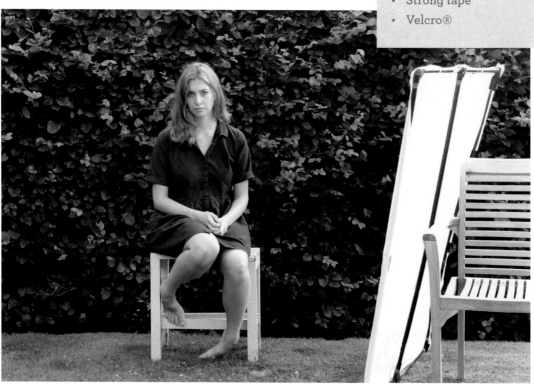

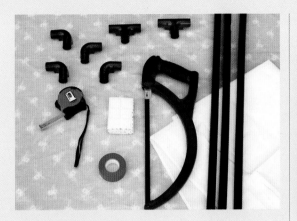

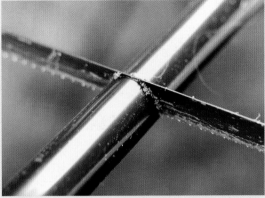

↑ **Supplies needed**

1. Plan the size of your diffuser. Measure your shower curtain and decide whether you would like to use the whole sheet or create something smaller. If necessary, cut down your shower curtain to size using scissors.

2. Once you have decided on the size of the rectangle, mark up your pipe to create three pieces the same size as the width of your shower curtain and four additional pieces, each half the size of the longer lengths.

3. Cut the pipe pieces to size using a saw.

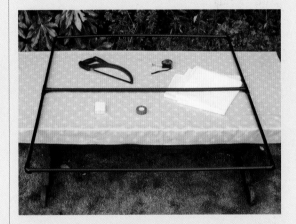

4. Join the lengths of pipe together using the right-angle corners and T-pieces to create a large rectangle.

Our homemade diffuser helps to reduce the harshness of late-morning summer sun.

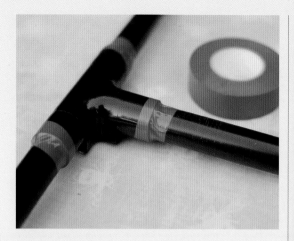

5. Place strong tape around the joints to secure them.

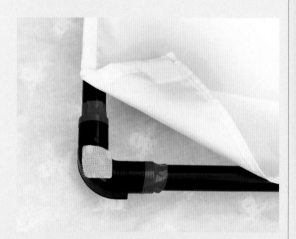

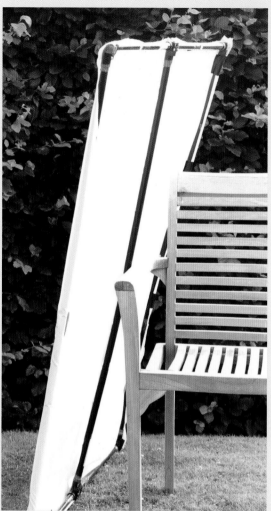

6. Arrange the shower curtain over the frame and attach it using Velcro® or a similar hook-and-eye fastener, making sure that the curtain is tightly pulled over the frame. Using a hook-and-eye fastener will enable you to remove the shower curtain and pack down the jumbo diffuser to use again.

8. When you're ready to take your photograph, place the diffuser between the subject and the sun.

← Strong sunlight can leave a model squinting.

Ask a friend or assistant to hold the diffuser for you, lean it against a table or chair, or improvise a stand using more pipe and connectors.

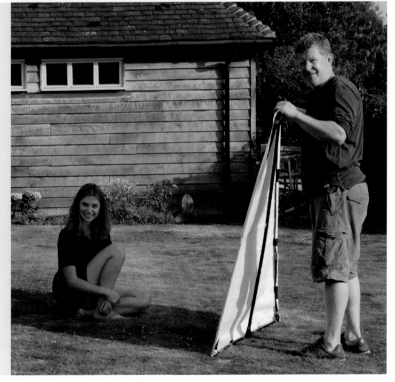

iPAD LIGHT PANEL

Working in low light can be challenging for any photographer. You can plan a perfect shoot only to find that the light has dipped and it is difficult to illuminate the model or subject you are trying to shoot. When working in low light, using an iPad as a coloured reflector can save your shoot. Fill your iPad or tablet screen with coloured or white light and use it to project a wash of light across the subject of your image. Experiment with different colours to create different moods for fun, colourful images. You could try making a triptych series (see pages 92–93) using one subject and a variety of colours, seeing how each affects the way you view the image.

COST: $$$
(if you already have an iPad or tablet!)
DIFFICULTY: ■□□

MATERIALS:
- iPad or tablet

↑ Dark lighting is particularly effective for making the most of the tablet's light.

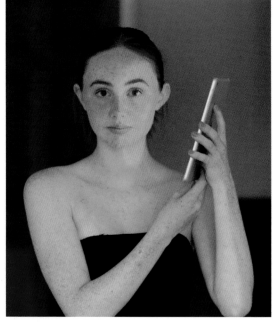

↑ A red background on the screen creates a warm glow on the subject.

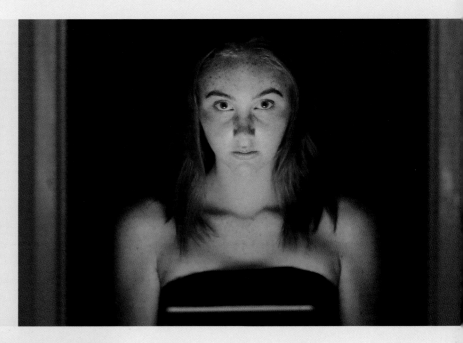

Some colours may not be especially flattering for skin tones, but can still create interesting effects, like the eerie, sinister feel of the green light in this shot.

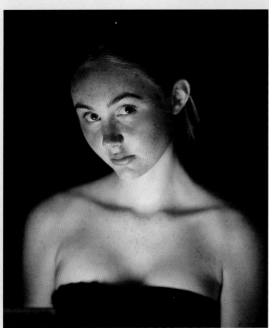

↑ A white background can be used in place of studio lighting.

1. Fill your iPad screen with a block of your chosen colour.

2. Turn up the brightness.

3. Ask the model to hold the iPad underneath or to the side of their face to create a strong wash of coloured light. Alternatively, ask an assistant to hold the iPad farther away to create subtler coloured light.

4. Experiment with different colours and angles.

BUDGET BEAUTY DISH

A beauty dish sits around and over the bulb of a flash or other light source, allowing the light to reflect around the dish and onto the subject. This eliminates the harsh central point of light from the bulb and creates a soft light for beautiful portraits. Like a lot of lighting equipment, beauty dishes are an investment. With this hack you can create your own easily and cheaply to elevate your portrait photography.

COST: **$$**

DIFFICULTY:

MATERIALS:

- Camera with flash
- 2 white paper bowls
- Pen
- Scissors
- 4 cocktail sticks

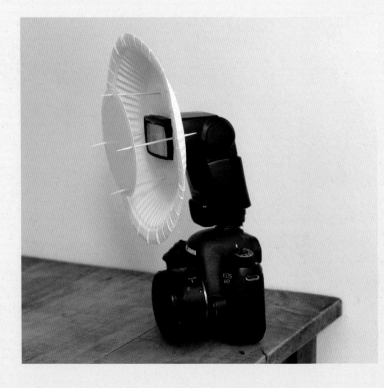

1. Place the camera's flash on the base of one of the paper bowls and draw around it using the pen.

2. Use scissors to cut out the section you have marked.

3. Place the bowl over the camera flash, slotting the flash through the cut-out section.

4. Cut out the circular base of the second paper bowl.

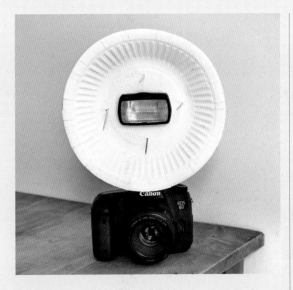

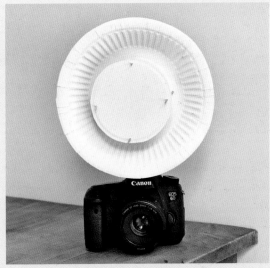

5. Pierce four cocktail sticks through the bowl around the flash as shown.

6. Stick the cardboard circle onto the cocktail sticks, being careful not to hurt your fingers.

↑ Bright, harsh light before the beauty dish is used

↑ Beautiful, even lighting using the budget beauty dish

CANDY-WRAPPER FILTERS

Filters have become an increasingly popular way to edit and enhance photos. Many programs now come with presets to add coloured hues to an image. Coloured gel filters on your flash or lens are also useful tools for changing the colour of a background or the appearance of an image. Using such filters is a fun way to shoot pop-art-style images, and you can make them yourself by using transparent plastic wrappers from sweets and chocolates. The brightly coloured plastic changes the mood of your images, and using a range of different colours while photographing the same subject can produce a vibrant sequence which you could use for a diptych or triptych (see pages 92–93).

COST: $$$
DIFFICULTY: ■□□

MATERIALS:
- Sweets or chocolates with transparent coloured wrappers
- Elastic band (optional)

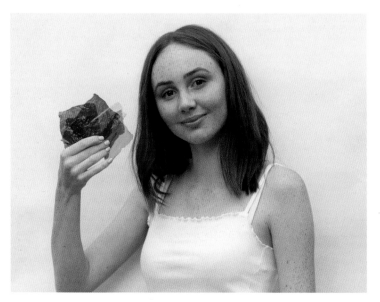

1. Find sweets with coloured transparent wrappers. Try to get a range of colours.

2. Either eat the sweets with family and friends or simply remove the wrappers.

3. Flatten out the pieces of plastic to remove creases.

3. Choose a colour and place the wrapper over the camera lens.

4. Stretch the plastic so it's tight and as flat as possible over the lens.

5. Secure the wrapper onto the lens with an elastic band or hold it in place as you shoot, being careful not to get your fingers in the frame.

6. Experiment with different colours.

If you find the colour effect to be too intense, you can decrease it in post-production.

PORTABLE SEAMLESS BACKGROUND

This portable photo background is easy to assemble and dismantle and can be used to create a smooth, fluid backdrop for photographing objects. Our hack shows you how to make a frame onto which your paper or fabric background of choice can be secured. The seamless nature of the background will eliminate the distracting right angle of a corner, along with other incidental background elements that might take attention away from your subjects.

COST: $$$

DIFFICULTY: ▮▮□

MATERIALS:

- 2 pieces of white foam board that are the same size
- 4 metal right-angle brackets
- 2 bulldog clips
- Large sheet of white paper or fabric
- Sticky tape

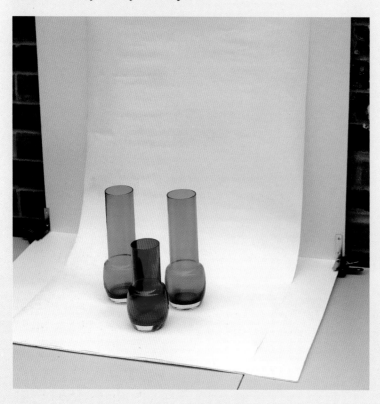

1. Place the foam board pieces at a right angle to one another.

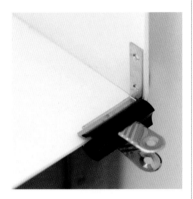

2. Place the metal right-angle brackets at each end, inside and outside of the corner where the foam boards join. Secure them using a bulldog clip.

3. Lay a piece of paper or fabric in the frame, curving it over the right-angle to create a seamless background.

4. Secure the paper or fabric with sticky tape.

5. Place your background in a well-lit area.

6. Position your product on the background.

The materials list calls for white paper or fabric, but you can use any colour. Heavy-duty clamps from the hardware store are handy for securing fabric onto the foam boards.

CAMERA RAIN BAG

Extreme weather can be a photographer's nightmare. You've planned a shoot for months, have got all your equipment ready, have already scoped out the location and when you arrive you are suddenly faced with a torrential downpour or heavy snow. Cameras are often very resilient and can withstand some rain, but too much moisture can lead to damage.

Waterproof cases and covers can be expensive and bulky. When shooting on location it is often helpful to pack as light as possible to keep you mobile. This simple hack uses a plastic bag as a waterproof camera cover and can be made quickly on the spot as soon as the rain hits.

COST: $$$
DIFFICULTY: ■☐☐

MATERIALS:
- Tripod
- Lens hood (see page 22)
- Plastic bag
- Rubber band

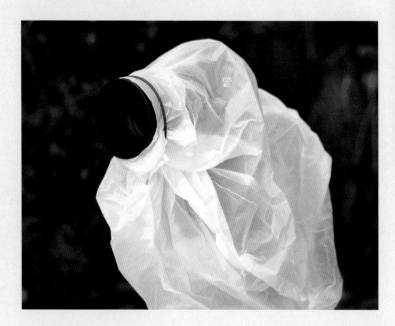

1. Place your camera on a tripod.

2. Place your lens hood onto your camera.

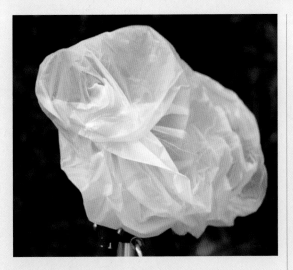

3. Place the plastic bag over your camera so it is completely covered.

4. Rip a small hole in your plastic bag and poke the lens hood through it.

6. Tear another hole at the back of your camera for the viewfinder.

Photo-worthy events happen in all kinds of weather. Be prepared!

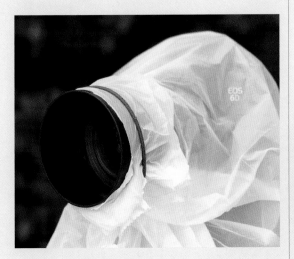

5. Stretch your elastic band over the lens hood so it holds the bag in place.

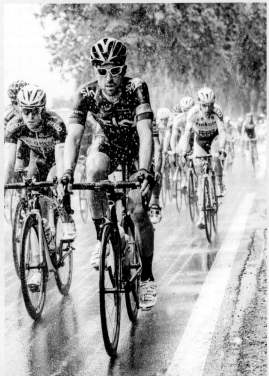

REFLECTIVE-CARD HACK FOR PRODUCT PHOTOGRAPHY

Product photography often requires clean, sharp and well-lit images of a single item against a plain background. This setup helps the product to pop out of the image and become the focal point. Booking studio space or purchasing lighting for this kind of photography can become expensive, but you can achieve crisp, impactful shots that are beautifully lit for next to nothing. This hack provides a simple way to bounce natural light onto a product from several angles using aluminium foil.

COST: $$$
DIFFICULTY: ▮▮▯

MATERIALS:

- Roll of tracing paper
- Sticky tape
- Roll of aluminium foil
- Scissors
- Large piece of strong cardboard
- 2 large books
- 2 food cans

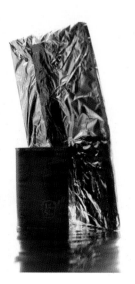

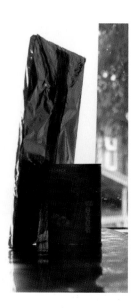

The homemade reflectors are easy to move to ensure that light is channelled where you need it. The tracing paper helps to diffuse the natural light to create an even wash across the product.

1. Place a table near a sunlit window or door.

2. Secure a large piece of tracing paper to the window to diffuse the light.

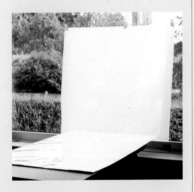

3. Wrap the cardboard neatly in aluminium foil and secure it (good side up) to the table.

4. Place your product on the foil.

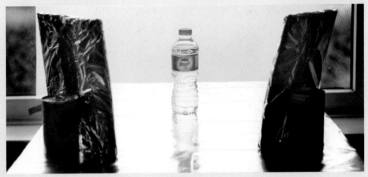

5. Cover two large books in aluminium foil, securing the foil with sticky tape.

6. Place the books against the food cans opposite one another and pointing towards the product.

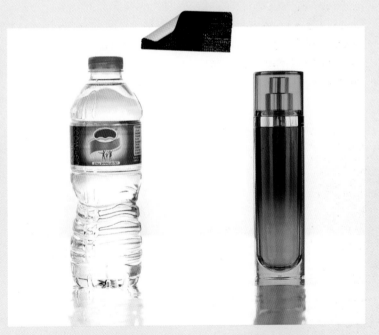

↑ The reflected light makes the water bottle pop out of the photo.

↑ The light shines through the translucent bottle, making it appear illuminated.

BEAN-BAG TRIPOD

COST: **$$$**

DIFFICULTY: ◼◻◻

Tripods are fantastic additions to your photographic tool kit, helping to stabilise your camera for brilliantly sharp shots. However, they can be bulky and if shooting in a small space or out on location where you are frequently moving, they can quickly become an inconvenience. This bean-bag tripod is easy to make and will be a compact addition to your photographic kit. When out on a shoot, simply place the bean bag on top of a high surface such as a fence or post and use it to stabilise your camera so you can take a perfect shot every time.

MATERIALS:

- Fabric bag
- Dry rice or beans
- Strong sticky tape or needle and thread
- Scissors

Late afternoon light can slow shutter speeds down enough to cause camera shake. Using a bean bag will prevent that.

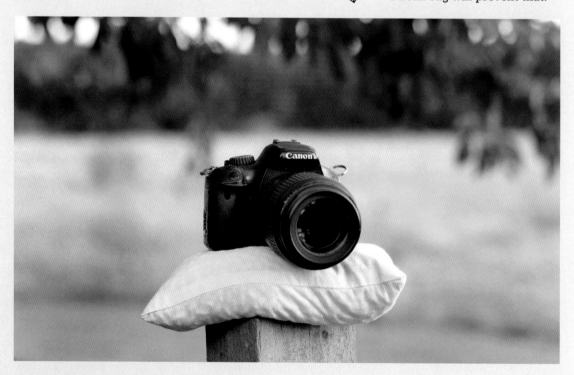

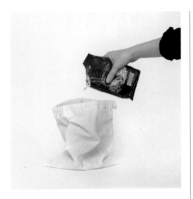

1. Fill the fabric bag with rice or beans.

2. Fold the opening to create a rectangle and secure the edge with strong sticky tape. Alternatively, you can sew the open edges down.

3. Use the beanbag to support and stabilise your camera while you shoot.

The bean bag works even for telephoto shots!

STRING STABILISER

Every photographer has experienced the agonising moment where you have meticulously planned and set up a shot or seen the perfect candid moment to capture, only to find that an unsteady hand has created camera shake in the final image. With this simple hack, you can stabilise your camera using a key and a piece of string.

COST: $$$

DIFFICULTY: ▮▯▯

MATERIALS:

- Piece of string
- Scissors
- 1/4-20 bolt
- Key

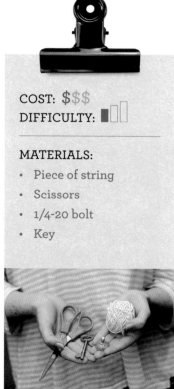

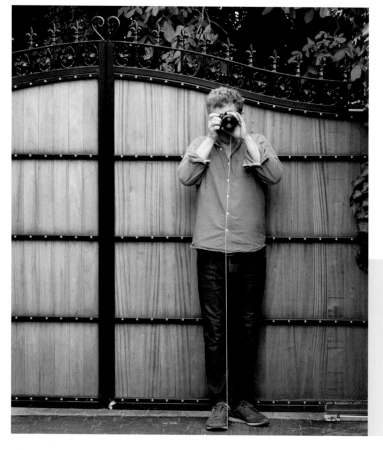

In low light, try using this hack instead of a higher ISO. See if you notice a difference in sharpness and colour saturation.

This highly mobile stabilising platform is ideal for capturing dynamic shots while out and about in the city. It even allows some slack for panning.

1. Measure your string so it is about 5cm (2in) longer than the distance from the ground to your chin.

2. Cut the string to length.

3. Tie your string tightly round the bolt.

4. Tie the other end of the string to the open eyelet in the key.

5. Screw the bolt into the tripod mount on the bottom of your camera.

6. Step on the key and hold the camera up to your face so that the string is taut.

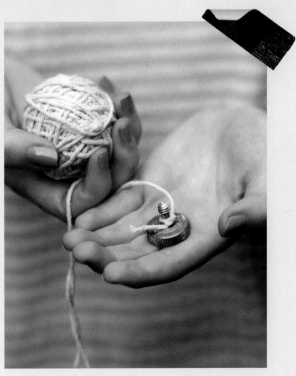

SHOOTING TRICKS

MATCH FILM BURN

Light leaks in film create a fiery, burnt haze in the corner of photographs. Since photography has become a more digital field, the look now gives a vintage feel, taking the viewer back to a time where damaged film or leaks of light could produce unplanned results. This effect can be recreated in digital photography using filters or photoshop, but you can also experience the same creative joy at the time of shooting. This hack uses real fire to create the glowing, burnt effect.

COST: **$$$**

DIFFICULTY:

MATERIALS:
- Box of extra-long matches

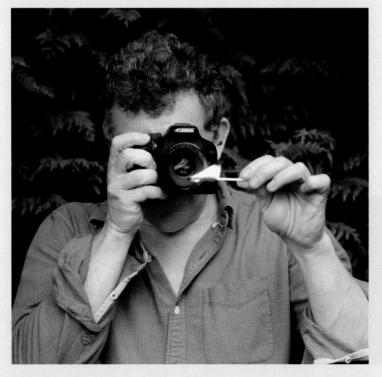

1. Set up your photograph.

2. Light a match and hold it in the corner of your lens. Don't let the match burn too low.

We advise using extra-long matches to give you more time to set up the shot and to protect your fingers.

We experimented with the
position of the burning match
for different effects.

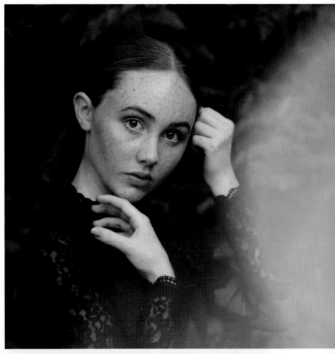

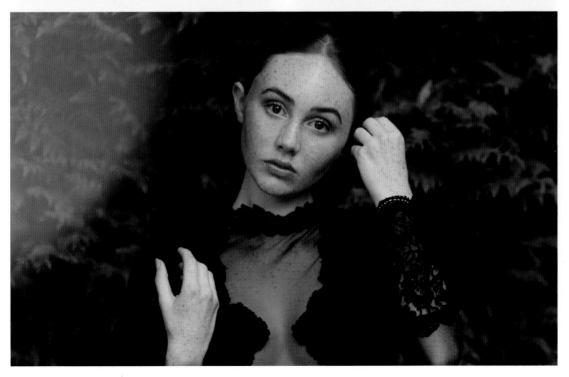

SHOOT IN PUBLIC

When working with a model or capturing candid images of your surroundings it can sometimes feel challenging to have the confidence to try new locations for your shoot. Public spaces such as parks and streets provide wonderful settings for atmospheric photos that are full of character, providing backgrounds that capture movement and life. If working with a model, the static nature of the subject among the bustle of people can create a striking shot.

COST: $$$

DIFFICULTY:

If working with a model, consider clothing, makeup and hair before you head out. It can be difficult to find places to change a look, so choose a versatile outfit.

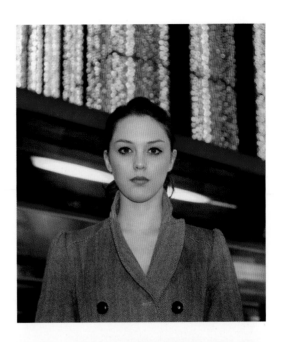

You are likely to come across other people who may be interested in what you're doing or unaware that you are on a shoot. Remember to be patient and have the confidence to focus on what you are shooting. It may take a bit of time to get the perfect shot if the area is busy, but with perseverance you can achieve an impactful image that captures the essence of the space around you.

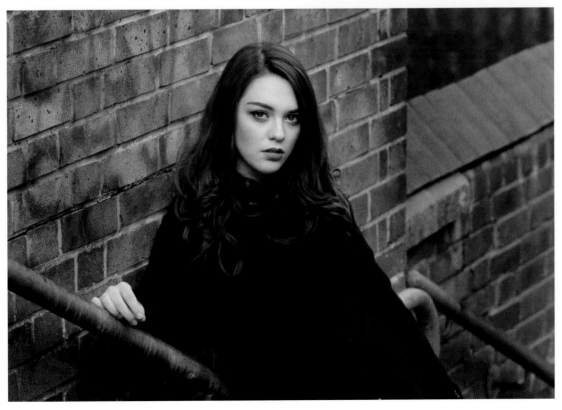

1. Plan out your shoot. Decide what what kind of theme or mood you want to capture.

2. Research public spaces near you or go for a walk in your local area to get an idea of what is available.

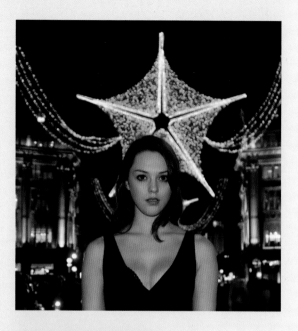

3. Check how busy the space is at the time of day you want to shoot. For example, if shooting in a busy street in a town or city, it may be best to plan your shoot for early morning when it is quieter. However, if you want to explore street photography, you might want to find a time of day that is busy and bustling with life.

4. If working with a model, meet up first to communicate your aims and ideas clearly.

5. Research similar photos and bring along a paper or digital ideas book to help you stay inspired.

→ Any one look can tell a variety of stories, depending on the setting. The 'little black dress' says night life in the top shot, while at right, it gives a sense of being lost or out of place.

When shooting in public places, planning is key. Find out whether there are any events that may affect your ability to carry out the shoot.

FINDING BEAUTIFUL LIGHT

When shooting with a model outdoors, knowing how to find beautiful light is essential to taking stunning photographs. As with artificial light, when you know how, you can manipulate natural lighting to highlight different features. Work out the direction of the light and move yourself and your subject accordingly to experiment with light and shadow.

COST: $$$
DIFFICULTY: ■□□

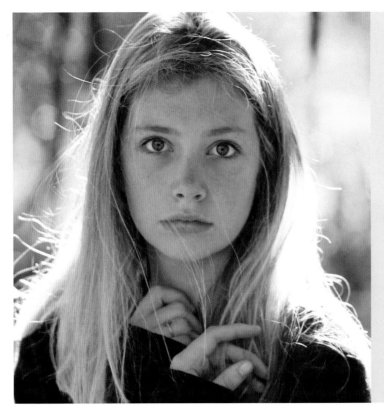

To capture a classic angelic glow, arrange the subject with rim lighting (where the light source is behind the subject). You can also choose to even out the light by reflecting it onto the subject's face, but this removes the halo effect.

The photographs shown here give some suggestions for how to find and use beautiful natural light. We hope these will be a creative spring board to help you use natural light when shooting.

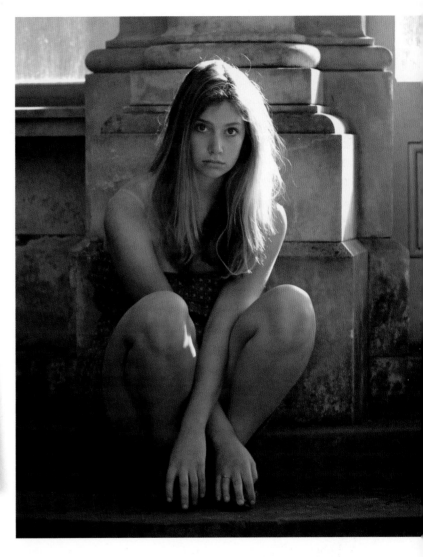

We always carry a reflector (see pages 18–19) with us when we're shooting outdoors. Sometimes, as in the shots you see here, we like to let the shadows be. But that doesn't always work – sometimes you need more light to fill in shadows or throw a catch light into a model's eye.

↑ Here, we intentionally sought out shadow by asking the model to sit in the shade of a dramatic architectural structure. This creates even light across most of her face and body, while her hair is highlighted by a strong light source from the side for a beautiful glowing effect.

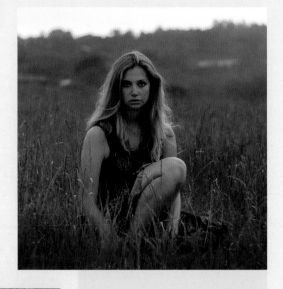

Although natural light gives beautiful results, always be careful to avoid direct sunlight, which will result in harsh, bright light with strong contrasts between light and shadow. Although this can be used to creative effect, on the whole it produces a visually displeasing result. If possible, try to seek out shade for soft, even light.

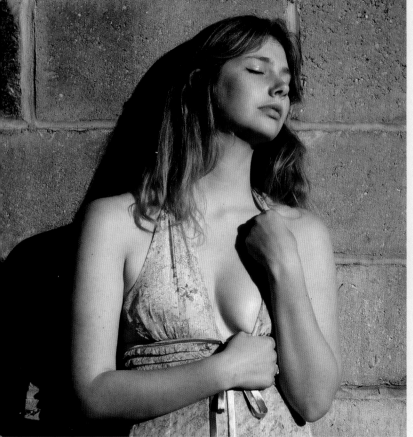

One of the best times to use natural light is in the 'golden hour', which appears twice in the day – after dawn and before dusk.

← Brighter sunlight features in this photo, and to work with this, the model has been directed to close her eyes. Here, the strong shadow has been used behind the model for a striking effect.

→ In this photograph, the natural light comes from one side. However, as the sunlight isn't too strong, a soft transition between light and shadow is created, drawing the viewer's eye to the illuminated eye of the model.

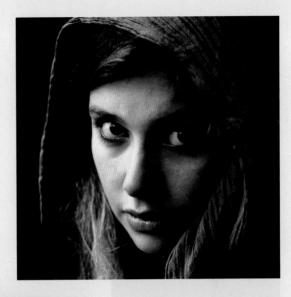

Here, as above, the light is channelled from the side, highlighting one side of the model's face, with the other gradually moving into shadow. This creates a sense of depth and shape.

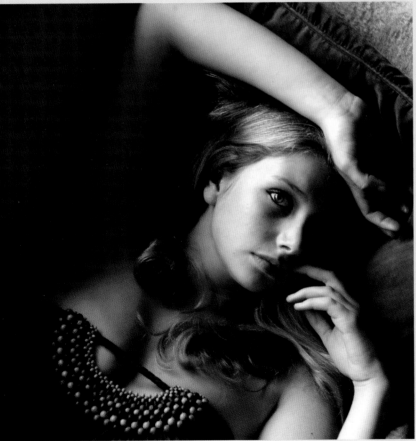

Beautiful light can also be found indoors by placing the subject of your photograph near a window.

LAPTOP BACKDROP

When shooting products for online shopping sites such as Etsy and eBay, you can make your items stand out by using an eye-catching background. Fairy lights and bokeh create particularly magical results but can take time to set up. With this hack, you can use a full-screen image on your laptop to place your product in any setting or against any backdrop. When searching other people's images online to use as a background, make sure you check that the photo has been uploaded for people to use for free, and always credit the photographer.

COST: $$$
DIFFICULTY:

MATERIALS:
- Laptop
- Product to shoot
- A3/A4 piece of plain card in white, black or grey
- Book

There are hundreds of bokeh backgrounds like this one available on the internet.

A striking background can help your online listing draw more attention.

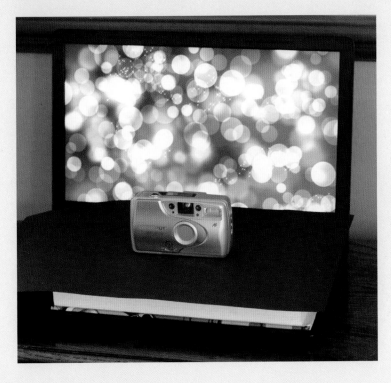

1. Find a background you like, giving the effect you want for your product.

2. Open the image to make it full-screen.

3. Place a piece of plain card over your computer keyboard, raising it using a book if necessary.

4. Place your product on top of the card and in front of your laptop screen.

GET CLOSER

When shooting portraits, it can become challenging to think of new ways to set up images or pose a model. Getting closer is a great way to add a different type of image into your portfolio. If you are comfortable working with a model, you can shoot this live by moving closer to them. Make sure you give the model some warning beforehand! The same effect can also be achieved by cropping in close on the image in post-production. By cropping tightly around the model's face, you can create an intimate, powerful photograph. In addition, if you have a lot of clutter or visual noise in the background, getting closer or cropping can remove anything distracting, allowing the viewer to focus directly on the subject of the image.

COST: $$$
DIFFICULTY: ▮▯▯

Original photograph with empty space in the background ⟶

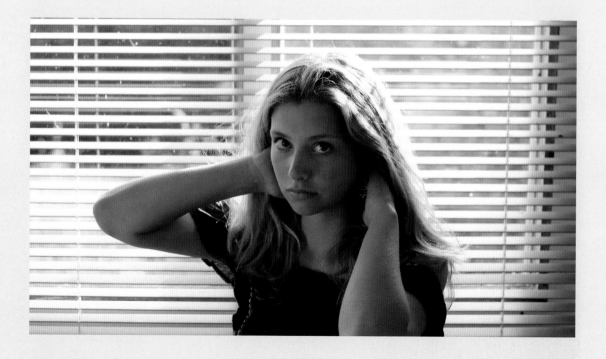

1. Take a portrait shot of your model.

2. In post-production, crop the image so there is less empty space around the model.

3. After cropping in tightly around the model, try an even closer crop, where the model's face almost fills the entire frame.

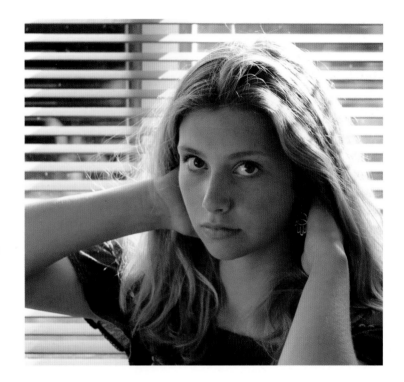

↑ The first crop places more emphasis on the eyes.

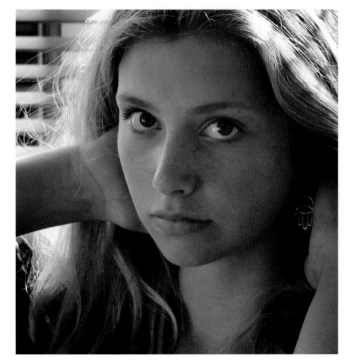

← The final crop brings the viewer into close proximity with the model. This creates an intimate, arresting effect and the eyes become even more prominent.

4. Experiment with shooting at close proximity to get the close-up at the time of shooting.

DIY LENS FLARE

COST: $$$
DIFFICULTY: ■□□

MATERIALS:
- CD

Lens flare is often considered a negative result in photography, with items such as lens hoods being used to eliminate it from photographs. However, used well, lens flare can impart a magical, summery feeling to your image. Using a CD, you can direct flared light into your image, controlling the direction of the light and where it lands across the frame. This technique works most effectively in bright light, where you are able to use the CD to bounce sunlight into the camera lens.

↓ A curve of coloured light creates a sunburst effect.

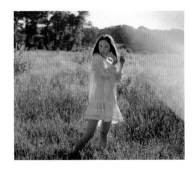

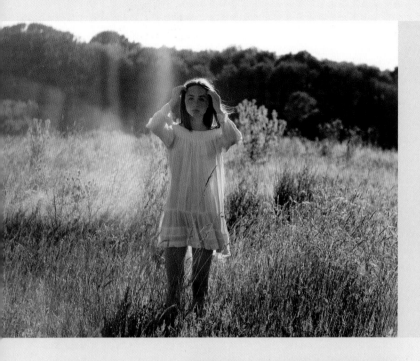

By experimenting with the angle of the CD and light source you can create softer, more ethereal, hazy coloured light.

→ The CD creates a vertical spectrum of light, framing the side of the model.

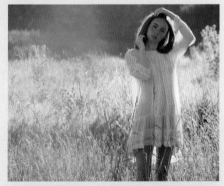

→ Here, a rainbow block of light adds interest to the space in the background.

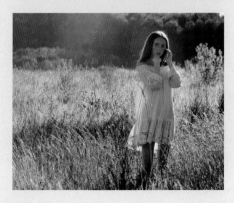

1. Remove the lens hood from your camera (if applicable).

2. Hold the reflective side of the CD underneath the camera lens.

3. Look through the viewfinder to see when the light flare intensifies in the frame.

4. Tilt the CD in different directions both underneath and to the side of the lens for varying effects.

TRY A PRISM

Glass prisms can be used to reflect coloured light or ghostly objects onto the subject of your image. Prisms are relatively cheap to buy and come in a variety of shapes and sizes. You will need to hold the prism in front of your camera lens, so it is useful to buy a prism long enough to give you space to hold it without inadvertently getting your hand in the frame.

Shooting with a prism often requires patience and some trial and error to get good results. You will need to move the prism in front of your lens to find an angle where it reflects light or images onto the subject. Twisting the prism and trying different angles allows you to curve and distort the image. Although it can be challenging to use, the unpredictable nature of the results can help to spark new creative ideas.

COST: $$$
DIFFICULTY:

MATERIALS:
• Prism

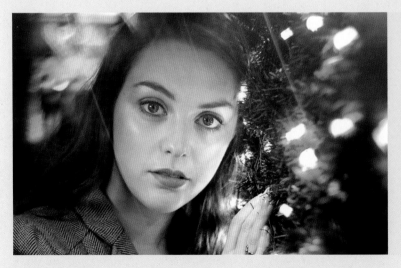

Try using the prism with various types of lighting to see what effects you get.

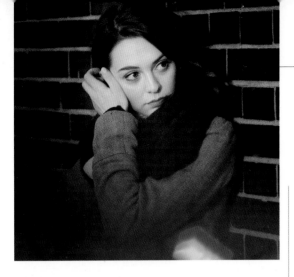

← The prism not only reflects coloured light but also creates a hazy, soft filter at the bottom of the image.

COLOURED LIGHT

1. Focus on the subject.

2. Hold the prism across the camera lens.

3. Move the prism, looking through the viewfinder to see when it is reflecting rainbow-coloured light onto sections of the frame.

4. In post-production you can experiment with saturation to make the coloured spectrum of light more or less vibrant in your image.

REFLECTING OBJECTS

1. Focus on your subject.

2. Decide on something in the background that you would like to reflect onto the subject.

3. Adjust the angle of the prism to reflect the background feature onto an area of the subject.

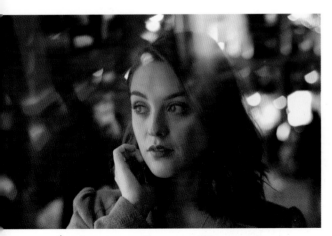

↑ The prism reflects small bursts of coloured light, along with elements from behind the camera, across the image.

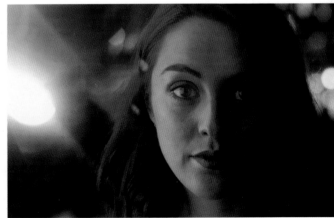

↑ The reflected coloured light creates a burst in the corner of the image, drawing the viewer's eye down to the model in the centre.

GO PSYCHEDELIC

This hack uses diffraction grating to create rays of coloured light across your image for a fun, psychedelic effect. It's a great way of adding an extra element to your portfolio or providing a different look with a model.

Diffraction grating disperses light and works particularly effectively when shooting directly into the sun or a bright light. This results in beams of colour, and when used with a continuous light, such as on a cloudless day or in a studio, it causes a rainbow effect. Diffraction grating can be bought as part of your photography kit. It is a small investment but produces wonderful results.

COST: $$$
DIFFICULTY: ▮◻◻

MATERIALS:
- Diffraction grating sheet or slide

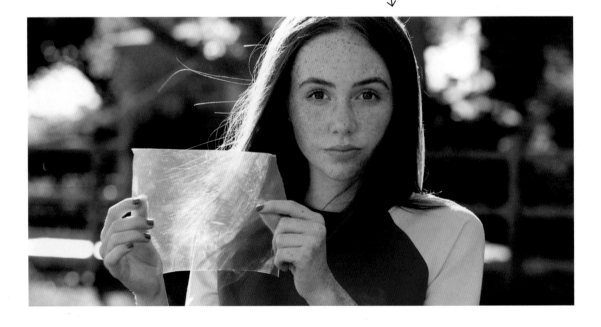

This piece of film can provide hours of fun!

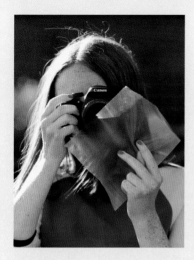

The vibrant beams of light create a striking, psychedelic effect.

1. Set up your shot.

2. Place the diffraction grating over the lens.

3. Experiment by moving the sheet or slide around in front of your lens.

Cover the lens only partially for a pleasing look that doesn't totally obscure the subject.

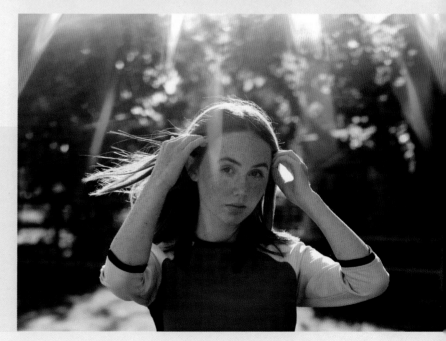

CRYSTAL DROP FLARE

COST: $$$
DIFFICULTY: ▮▯▯

MATERIALS:
- Glass or plastic crystals

As explored in Try a prism (see pages 64–65) and Go psychedelic (see pages 66–67), reflecting rainbows of light into your image can create beautiful effects. Using glass or plastic crystals from a craft store or an old chandelier is another great way to add rainbow-coloured beams of light across your image. The faces of your crystal will add different-shaped beams of light, creating a pretty effect.

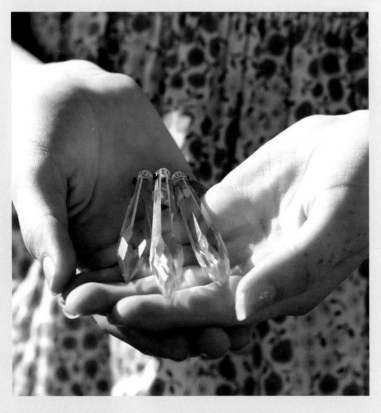

1. Either buy long crystals from a craft store or remove them from a second-hand chandelier.

2. Hold the crystals in front of your camera lens. Adjust the positioning and the angle to flood coloured light across different sections of your image.

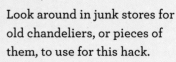

Look around in junk stores for old chandeliers, or pieces of them, to use for this hack.

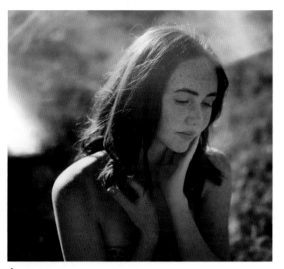

↑ Holding a crystal in front of the lens creates a rainbow effect across the top of the image.

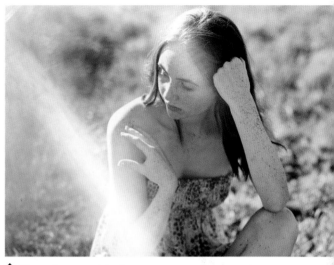

↑ Experiment with the positioning of the crystals to move the rainbow.

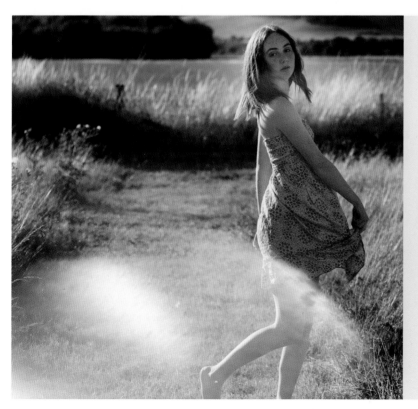

Effects like this one can give a strong sense of atmosphere to an image, and make the viewer feel almost as though they are in the scene.

RULE OF THIRDS

One of the most well-known principles of photography is the Rule of Thirds. The Rule of Thirds splits images into nine squares using two horizontal and two vertical lines. Focal points in the image and background are then placed in various points on the grid to make a compelling composition. The rule ensures that the viewer's eye is drawn to the most fundamental parts of the image.

As with all rules, there is space for this one to be broken. Photos can have a strong composition without the rule of thirds, but it provides a useful place to start to ensure that you get a visually striking, well-thought-through image.

COST: $$$

DIFFICULTY: ▮▯▯

1. Set up the scene or subject.

2. Either use the grid on your camera or imagine a nine-square grid with two horizontal and two vertical lines.

← In this image, the eyes line up with the top line in the Rule of Thirds.

↑ The model here is aligned with the right-hand line.

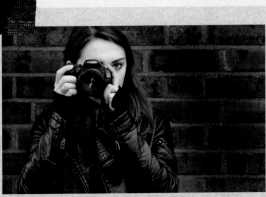

↑ Here, a prop becomes the focal point as it is placed at the top-left intersection.

↑ The subject's eyes align with the top-left point which strongly draws the viewer's eyes to this focal point.

↑ The eyes align with the top-right point. The prominence of the background on the right-hand side helps to give context to the image.

3. Choose the focal point of your image and place this on one of the points where the horizontal and vertical lines meet.

4. If you have a horizon line, try placing this in the top third of the image to allow space for the rest of the scene.

5. Experiment with placing the focal point in different spots on the grid.

6. If you weren't able to capture the perfect Rule-of-Thirds image in the camera, try cropping in post-production to get it right.

CHOOSING A FORMAT

Choosing how to present your photograph is an important creative decision. This hack explores the use of various formats, and how each changes the way the viewer interacts with the photo. You'll most likely use post-production to achieve the various formats, though portrait format is simple to capture in-camera.

CINEMATIC
In cinematic photography, the aim is to create an image that looks as though it could be a still shot from a film. This is a great choice if you are trying to display a strong sense of emotion or narrative in your image.

COST: $$$
DIFFICULTY:

MATERIALS:
- Editing software

Consider both the subject and the background and how they interact with one another to create a story.

PORTRAIT

Often focusing on the head and shoulders,
although not limited to this, a portrait
image draws the viewer's focus towards
the face and eyes of the subject, creating
an intimate experience.

Portrait format
helps to showcase
a sense of
character and
emotion.

**A square crop creates
a sense of immediacy
and balance.**

SQUARE
With a square crop you can make the
most of centrality. This format creates an
impactful image where the viewer is
drawn into intimate proximity with the
subject of the photograph.

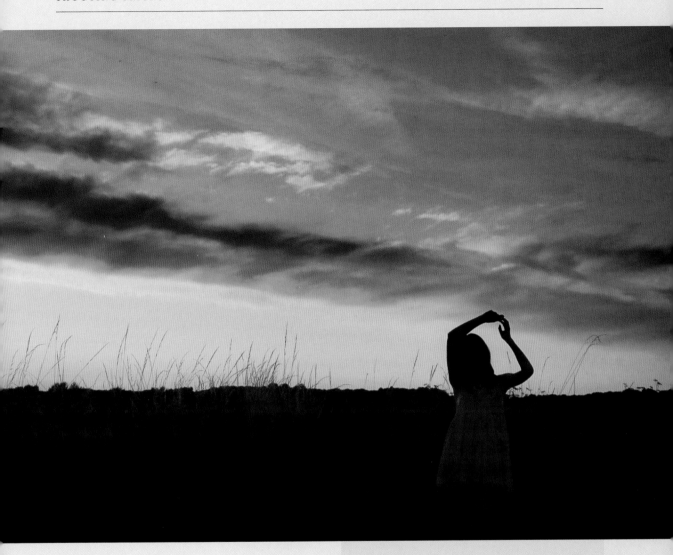

PANORAMIC
A panoramic format shows a wide view
of a scene or location. This gives a
360-degree impression of the image,
allowing the viewer to see more of the
context of the location of the shot.

Panoramic photography
works particularly effectively
for landscapes or cityscapes
although you can also present
a subject within the photo
to create a sense of story.

FREELENSING

Freelensing enables you to create beautiful, soft blur in your images. By detaching the lens and tilting it from left to right, you can control the level and positioning of the blur in the image. The soft blur will become very hazy, adding a dreamy quality to the image. The technique takes some patience and can take a while to master, but it produces unique results.

COST: $$$

DIFFICULTY:

MATERIALS:

- Interchangeable-lens camera

Dismount the lens from the camera, but keep it close.

1. Set your camera to manual focus.

2. Make sure your camera is set so that the shutter will fire with the lens detached.

3. Put the aperture at the widest setting to get a shallow depth of field.

4. Set the focus to infinity.

5. Set up your subject.

6. Detach the lens from the camera and hold it just in front of the camera with a small gap between the two.

7. Tilt the lens until the main focal point is in focus, leaving the rest of the image in a hazy blur.

8. Continue to adjust the position of the lens to experiment with different points of focus.

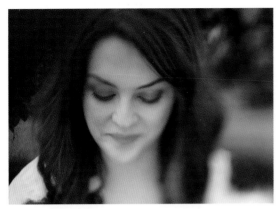

↑ The blur moves across the model's face in this image, creating a sense of slow motion.

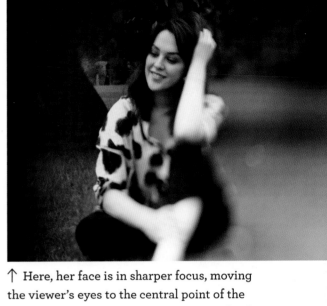

↑ Here, her face is in sharper focus, moving the viewer's eyes to the central point of the image. The heavy blur around the outside of the frame allows her face to stand out more.

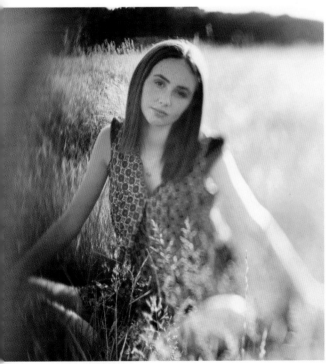

↑ Some interesting distortion can occur, like in this shot, which appears to have been taken through a door viewer.

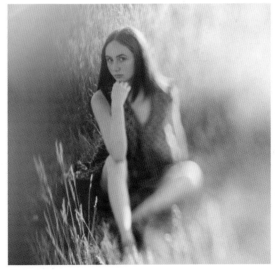

↑ Having nearly the whole frame blurred gives the image a dream-like quality.

CONVERT TO BLACK AND WHITE

COST: $$$

DIFFICULTY: ▮▯▯

MATERIALS:
- Editing software

Black-and-white photography has always been incredibly popular and provides classic, striking images. Many photographers choose to shoot entirely in black and white. In black-and-white photos, more prominence is placed on the contrasts and gradients between light, darkness and shade.

You may want to experiment with a black-and-white series in your own work. If you are shooting in colour and have an image that is jarring due to strong, garish or clashing colours, try converting the image into black and white. Using this hack can help to eradicate these issues and leave you with a strong, visually appealing image.

Though the colours in the left-hand image are harmonious, we found converting it to black and white added depth.

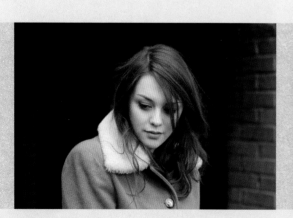

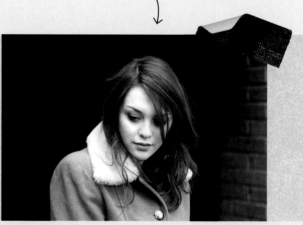

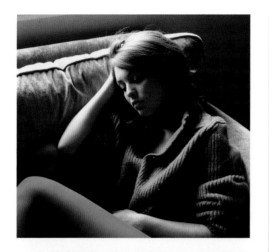

Texture and changes
in light are often more
striking in black and white,
and the viewer can use their
own imagination to create
colour in their mind's eye.

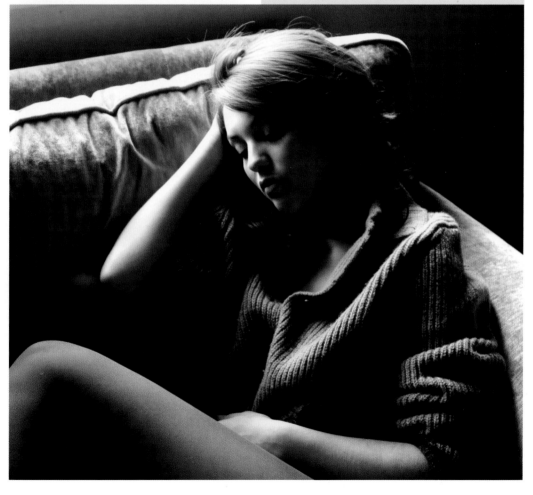

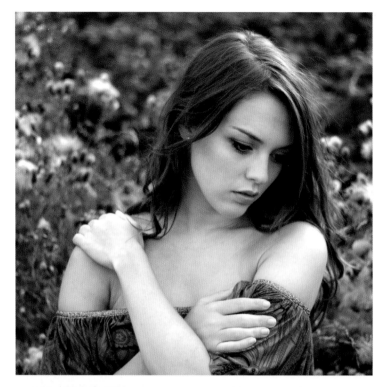

← Converting an image
to black and white can impart
a sense of timelessness.

→ Black and white can also
change the whole mood of
an image.

↑ The presence of opposite or complementary colours helps an image to convert well.

↑ The contrast in tones and gradients between the colours is accentuated.

1. In post-production, select photographs that would work well in black and white. These could include images where the background is too cluttered with colour or where the range of shades is particularly strong.

2. Many photo-editing programs have functions that allow you to quickly convert your image into black and white.

3. Experiment with the hue and saturation settings to create the range of grey shades you want in your image.

4. If you are confident that you want a black-and-white image, try setting your camera to black and white when out on a shoot.

↑ The tones are similar and the colours not different enough to create interest.

↑ Now the wash of similar tones is punctuated with rich shadows to hold the viewer's eye.

OBSCURED FOREGROUNDS

COST: $$$
DIFFICULTY: ■□□

MATERIALS:
- Editing software

In any composition, the boundaries of the photograph itself are a natural frame for your image, but using compositional elements to add more framing into your photo draws the viewer strongly into the image. These framing elements also contribute a sense of depth through layers.

Obscured foregrounds can be obvious, for example when shooting through a window or a door, or they can be more subtle. By placing features such as tree branches in the foreground surrounding the subject, subtle framing is achieved, marking the space around the subject.

There is an element of framing from the metal of the car door, but more obviously from the window.

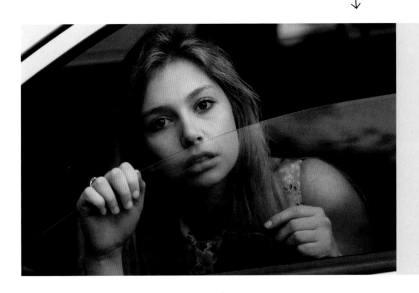

Framing with an obscured foreground can act as a mechanism to lead the viewer's eyes.

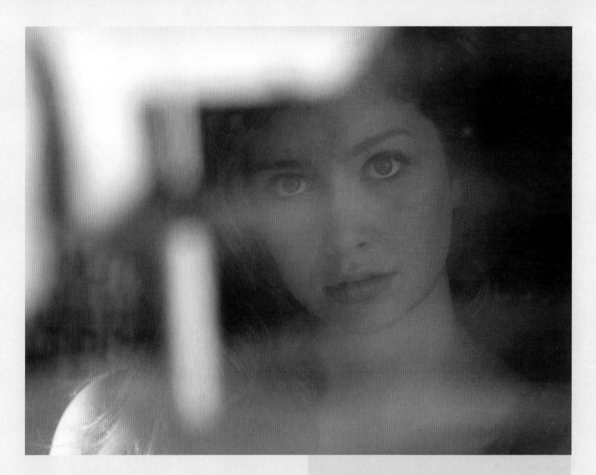

1. Find an object that will be in the foreground of your image, roughly framing the subject behind.

2. Place your model or subject behind the frame.

3. Ensure the focal points of your image can be seen and are strongly in focus. For example, if focusing on a model's eyes, be sure that they aren't covered by your framing object.

A framing device need not always be an object – it can even be light or shadow.

4. Focus on the subject so that the frame in the foreground is out of focus.

COORDINATE YOUR COLOURS

COST: $$$
DIFFICULTY: ▮▯▯

MATERIALS:
- Props, accessories, clothes or background with matching colours

An easy way to create a well-composed image is to incorporate coordinated colours into your shot. This requires some planning before the shoot. You will need to find your location, think about the colours available to you and pair these with outfits, props or accessories in similar hues. You can also use the colour of a model's eyes, hair or skin to coordinate with other elements in the image. Try to have three elements in the photo with subtle or bold pops of the same colour hue to create a cohesive image.

1. Plan ahead. Decide which colours you would like to work with and find a background or accessories with similar colours.

2. If working with a model, ask if they have clothing or makeup in the colour you are shooting.

3. Set up your photograph. You should aim to have three pieces with the same colour.

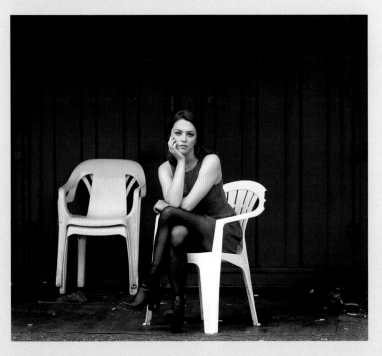

← A blue background was the starting point. We selected a blue dress and also captured a blue plastic bag, which happened to be on the ground.

→ We chose a vibrant orange
background. The model was asked to
wore an orange dress, and to use
bronze-toned makeup to further
match with the background.

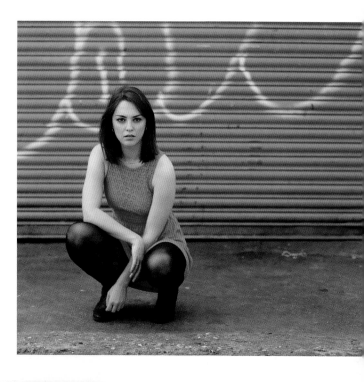

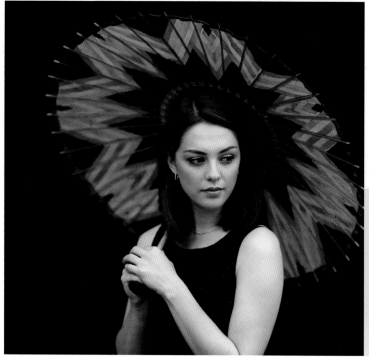

← We were keen to highlight
the beautiful parasol we had
brought as a prop for the
shoot. Rather than focusing
on the pops of colour, we
chose a black background
and dress to match the black
in the parasol.

A pop of colour against
an absence of it can be
just as effective.

POSITIVE & NEGATIVE SPACE

Positive and negative space are important parts of composition and free elements that you can use to enhance your images. Thinking about how you use them in your images can take your photography to the next level.

Experimenting with positive and negative space can change the way a viewer interacts with an image. You can flood an image with positive space by getting in close (see pages 60–61) or including lots of pieces of visual information. By contrast, you can experiment with images that predominantly use negative space to create an expansive feel. The way positive and negative space interact with one another within the image, and the balance you strike between the two, will affect the visual information that the viewer takes in.

COST: $$$

DIFFICULTY: ▮▮▯

Using positive space: the pattern effect is created by layering vintage cameras.

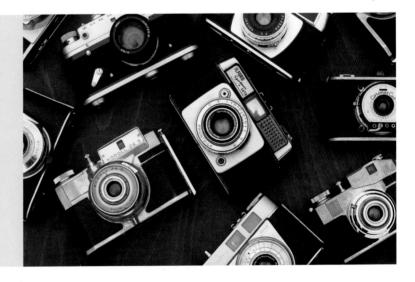

Positive space refers to the part of an image that is considered the subject. There can be one subject presented within an image or several.

These images are a starting point to give you some inspiration for how to use positive and negative space. Next time you are shooting, consider your background – how much space is positive and how much is negative? What could you change and what effect would it have?

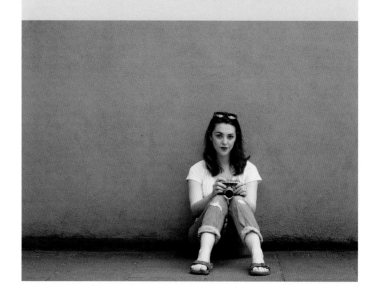

Negative space refers to anything that is not considered the subject of the image, for example colour or sky in the background.

→ Using negative space: the subject is placed in the bottom third of the image (see Rule of Thirds, pages 70–71), leaving a large amount of negative space. The eye focuses in on the subject and isn't distracted by anything else in the image.

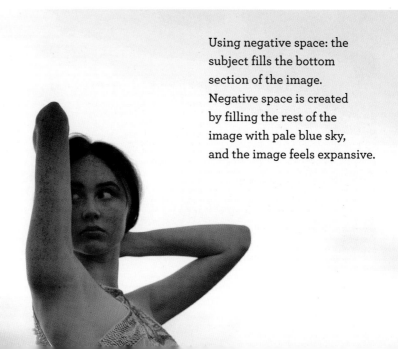

Using negative space: the subject fills the bottom section of the image. Negative space is created by filling the rest of the image with pale blue sky, and the image feels expansive.

MIRROR, MIRROR

This no-cost hack can be achieved with any mirror you have at home. Mirrors provide a great tool for shooting an implied candid shot. By shooting into the mirror, ensuring that you and the camera are not in view, you can look through the eyes of the model, seeing what they see as they too look into the mirror. Alternatively, you can use the frame of the mirror to create a frame within your picture. Finally, a mirror can provide a fun way to take a self-portrait.

COST: $$$
DIFFICULTY: ▮▯▯

MATERIALS:
- a mirror
- glass cleaner (optional)

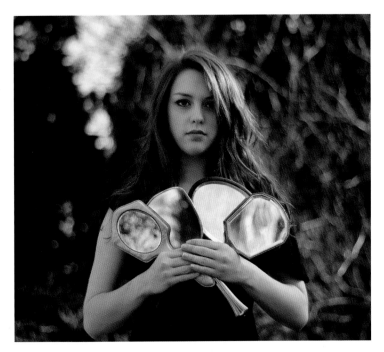

In this photo the mirrors are pointed towards the camera but are positioned so the photographer can't be seen. This creates a ghostly effect, asking the question of who is taking the image and why they are hidden.

1. Clean the mirror using glass cleaner to remove any dust or smudges.

2. Ask your model to sit in front of the mirror.

3. Either direct the model to look at themselves in the mirror to create an implied candid effect, or ask the model to stare directly into the camera for a more intimate feel.

4. Include the full frame of the mirror to frame the subject.

5. Position yourself so that you cannot be seen in the shot.

6. Alternatively, include your own reflection in the mirror for a self-portrait.

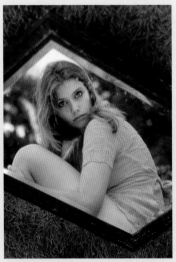

↑ A rectangular frame effect is made, creating an image within an image.

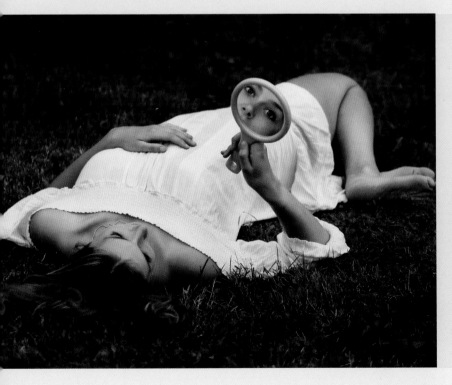

Experimenting with the positioning of the mirror can create a surreal effect, and you can use it to show a facet otherwise not revealed in the image.

GOLDEN HOUR

The golden hour is the period just after sunrise or just before sunset. It is often hailed as one of the most beautiful times to take photos due to its soft, warm light. During this time the light is less intense, and longer shadows are often produced. As the sun is lower in the sky, the light is often more diffused, creating an attractive, even light across the image. It's a soft, glowing light that gives a nostalgic, fairytale quality to photographs. It is also often a wonderful time to create halos of light surrounding a subject.

Shooting during any specific time of day requires forward planning. Think about the location, what shots you want to capture and how you're going to set them up. The instructions outline a good way to approach shooting in the golden hour, but it's down to the individual photographer to experiment.

COST: $$$
DIFFICULTY: ▮▯▯

MATERIALS:
- Outdoor location

The golden hour provides beautiful reddish-orange light.

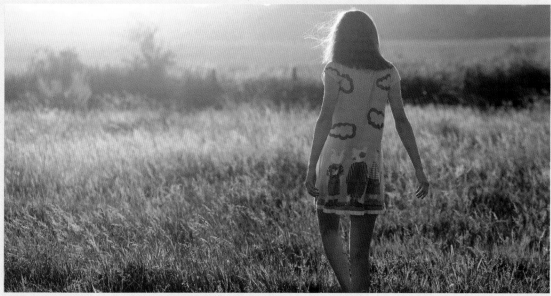

1. Check what time golden hour is likely to occur before you plan the shoot.

2. Arrive at your location early so you can set up before the light hits. If you are shooting with a model, ask them to arrive ahead of time so you can ensure you're both ready to capture the best light possible.

3. As the light is soft and diffused, you will be able to place your subject facing the light without it appearing too harsh.

4. If you want to create a halo effect, place the subject in front of the sunlight and shoot towards the light. This can also be used to create flare in the image.

5. If shooting a landscape or including one in the image, the golden hour provides a perfect time to shoot the sun directly as you can capture a beautiful golden orb.

6. Long-exposure shots also work wonderfully during this time.

↓ A fiery halo effect is created with the warm light behind the subject.

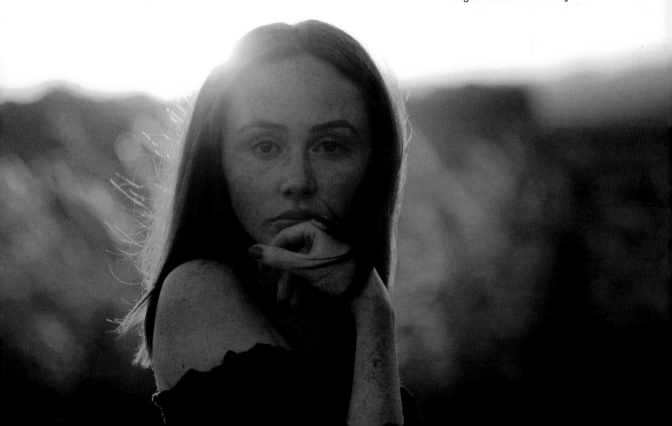

CREATE A DIPTYCH OR TRIPTYCH

Polyptychs are images that are split into several different sections. A diptych is split into two and a triptych into three. This technique was frequently used in Renaissance art where paintings related by a central theme were placed into several panels.

The technique can be used to tell a story across several images, much like a cartoon, or to explore multiple sides of a central idea. For example, you could shoot a sequence of photos exploring the same landscape at different times of day or periods in the year, looking at the effects of time on the scene. When working with a model, diptychs and triptychs can be used to show different emotions or expressions, creating an exploration of the model's character.

COST: $$$
DIFFICULTY: ■□□

MATERIALS:
- Editing software

This triptych uses the same model, location and outfit to achieve a uniform feel across the images.

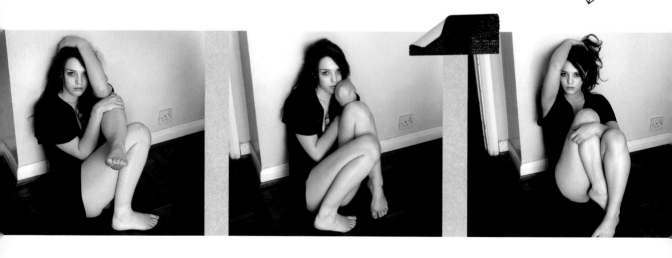

1. Decide on a theme or central idea to link your shots.

2. Plan several images which would tell a story or explore the idea.

3. Using photo-editing software, crop the images so that they are all the same size.

4. If making any changes to colour saturation or exposure, try to make this uniform across all of your images.

5. Open your two or three images and place them side by side.

6. Either arrange the images so they sit exactly next to one another or include a small area of framing for each one.

Black and white is usually best for polyptychs, because colours in the images can distract from one another.

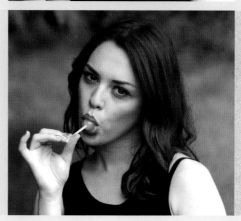

TAKE ON A PHOTO CHALLENGE

Stuck in a photographic rut? Taking on a photo challenge is a completely free way to push yourself and explore new ideas. Consider where you trip up so you can practise and improve, or choose something you're passionate about such as food or fashion. Next, set a time frame – will you shoot a photo every day for a year, once a week or just incorporate a challenge into each shoot you do? Once you've completed your challenge look back over all your images and reflect on what you've learnt.

COST: $$$

DIFFICULTY:

MATERIALS:
- Theme such as disposable cameras, food, photo a day, outfit photos, polaroids

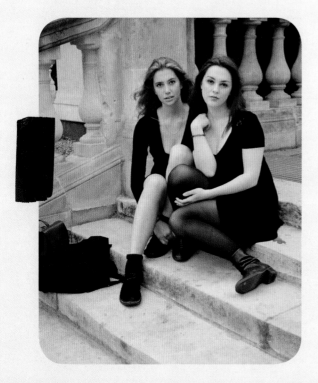

1. Choose your photo challenge – consider what you want to develop in your photography. Do you want to create a memory of something important each day for a year? Do you love the immediacy of disposable film and polaroid?

2. Decide how regularly you want to shoot and how long you want to challenge yourself for.

3. When you've finished your challenge, look back over your work, review what you've learnt and share your results with others online or in person.

DISPOSABLE-CAMERA PHOTO CHALLENGE

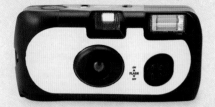

Take a disposable camera
on every shoot and challenge
yourself to take quick snapshots.

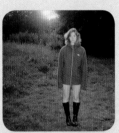

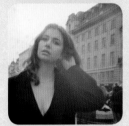

If you are used to a DSLR, this will
force a change from carefully
planned settings and shots.

Digital cameras give instant feedback,
but waiting for the film to be completed
and the photos to be developed can make
you spot different elements of your
images and prompt new ideas.

CAMERAS

PINHOLE CAMERA

Pinhole cameras provide a simple way to take atmospheric photos. A pinhole camera has no lens, but just a small hole that acts as an aperture. Light passes through this hole to create an image on the other side. The images are rarely sharp but certainly have their own vintage charm. Pinhole cameras require long exposure, so there is often motion blur in the images. This can translate to a feeling of movement or a ghostly effect.

Pinhole photography provided an early way of capturing images. Although photographic technology has become far more advanced, returning to this style can add variety to your repertoire. It's also a fun experiment to get the creative juices flowing!

Pinhole cameras can be made from all manner of things, including shoe boxes, paper or even a peanut. You can also make a pinhole with your DSLR camera using this easy hack. Pinhole photography requires a little trial and error, but we think you'll find it's worth the effort.

This modern feat of engineering can easily be reverted to photography's most basic elements.

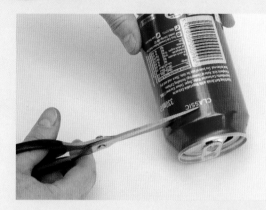

1. Cut a square out of your drinks can that fits within the back of the lens cap. Be careful of your hands as the edges may be sharp. Alternatively, you could use aluminium foil.

3. Push the needle through the metal to make a hole. It is advisable to do this into an eraser so you don't damage any surfaces. The hole will need to be as small as possible, so use the tip of the needle. (This hole should be smaller than the one you will drill into the lens cap.)

2. Use the abrasive sponge to rub off the shiny coating of the drinks can.

4. Mark a dot in the middle of your lens cap.

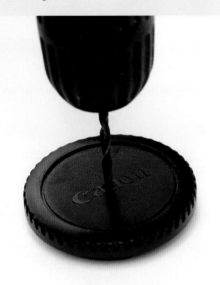

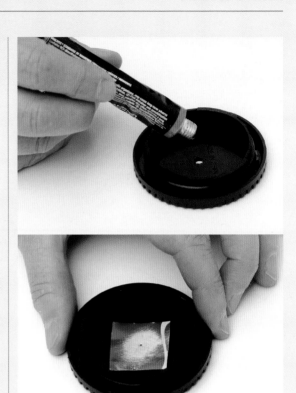

5. Using the drill, make a hole through the lens cap in the spot you marked. Place a piece of sponge below the cap to protect the surface underneath.

6. Make sure the hole is smooth so the light has a clear passage to travel through.

7. Glue the square of metal to the back of the lens cap, making sure the hole in the lens cap is completely covered and the hole in the metal is approximately centred.

In its most basic form, a pinhole camera is a light-tight container with a hole that you open to expose a light-sensitive medium inside. For this version, to take a picture, you simply press your camera's shutter button.

Experiment with shutter speeds and a variety of subjects and settings.

THROUGH THE VIEWFINDER

Through-the-viewfinder photography is a fun and creative way to achieve vintage, filter-effect photography. The basic principle involves taking a photo of the viewfinder of a vintage twin-lens reflex (TLR) camera with a digital camera. Using the TLR camera, you compose your image and then take a photograph of what appears on the viewfinder.

The TLR camera itself does not need to be functioning, and therefore you can pick up a cheap vintage camera from a second-hand store. The Kodak Duaflex and Argus 75 are commonly used for this technique, but you can experiment with any TLR camera.

The photo will be in a square format, and dust and marks on the viewfinder add to the vintage effect, creating a hazy filter over the image. You will need to crop the photo in post-production, and by leaving a black border from the edge of the view-finder, you can create a strong frame. The glass viewfinder itself can cause a lot of flare, so it is necessary to build a dark tube to shoot through. This hack will show you how to do it cheaply!

COST: $$$
DIFFICULTY: ▮▮▮

MATERIALS:

- TLR camera
- Ruler
- Corrugated cardboard
- Pen
- Craft knife
- Strong tape

1. Measure around your viewfinder camera.

2. Draw a long rectangle on a piece of card, the width of which should be equal to the circumference of the TLR camera.

3. Mark up the rectangle to create four smaller rectangles, each the width of one side of the TLR camera.

4. Draw a square at the top of one of the rectangles, roughly the size of your DSLR lens.

5. Cut out the rectangle.

6. Score along the vertical lines and tape the open edges together. This should make a long tube that can fit over your viewfinder camera.

7. Cut out a hole at the bottom of the tube where the viewfinder lens sits. This will allow you to see an image in the viewfinder through the tube.

8. Cut a hole to fit your DSLR lens in the square at the top.

Permanent Marker

↑ Here, the viewfinder made for a candid snapshot effect.

9. Secure the square to the rest of the tube so that light from outside will be blocked out when you place your camera through the hole.

10. Place your DSLR camera into the top of the tube and place the bottom of the tube over the TLR camera.

11. Move the TLR camera to face the object you want to shoot.

12. Adjust the positioning until you can see the image on the screen of your DSLR camera.

13. In post-production, crop your image to a square, leaving a black border surrounding the image.

↑ The vintage effect adds charm to these models.

← The black border serves as a frame, drawing the eye into the centre of the image. This effect is further enhanced with the pose.

↓ Photos taken through the TLR viewfinder will be backwards. Flip them right or leave them!

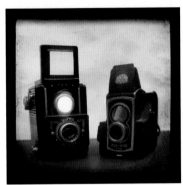

↑ This technique works effectively for shooting images of interesting objects.

→ The square format creates a vintage instant-film effect.

CAMERA-PHONE MACRO LENS

COST: $$$
DIFFICULTY: ▮▮▯

MATERIALS:
- Laser pointer
- Hair pin
- Camera phone
- Sticky tape

Macro lenses allow you to photograph small and detailed images close-up. They can help you capture natural patterns or show the intricacy of items. Macro photography often requires expensive lenses and camera bodies. Camera phones now take high-quality, sharp photos, but their minimum focusing distance can leave something to be desired. With this simple hack, however, you can do macro photography with your phone.

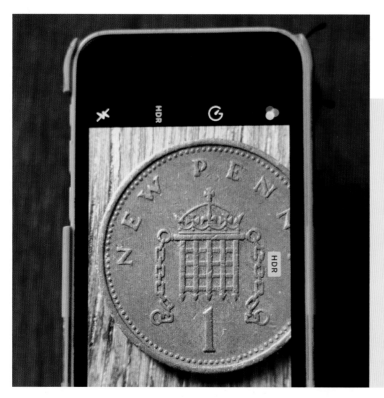

Crisp, close-up image using the camera-phone macro hack

By placing the lens from a laser pointer over the camera on your phone, you can magnify your image, allowing you to get in close and capture the detail of your subject.

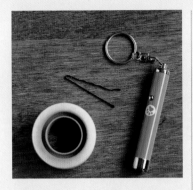

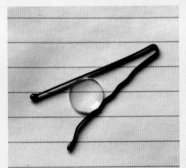

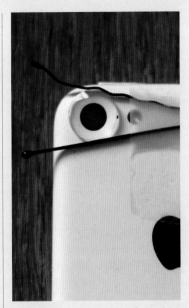

1. Take apart the laser pointer and find the small focusing lens.

2. Remove this and set it aside.

3. Open the hair pin and use it to hold the focusing lens from the laser pointer.

4. Place the lens (held by the hair pin) over the camera on your phone.

5. Use sticky tape to affix the hair pin to your phone.

← The vanishingly small depth of field of a macro shot can turn everyday objects into exquisite compositions – but be aware you're going to need a strong light source.

MACRO TUBE

We showed you how to get great close-up shots with your phone without spending hundreds or thousands on equipment (see pages 106–107). This hack will help you do the same with your SLR. We'll show you how to make a DIY macro lens using a cardboard tube. A macro tube (often called an extension tube) works by placing the glass elements in the lens farther away from the focal plane, which allows a much closer focusing distance than the standard one to three feet that most lenses allow. When shooting, you'll need to practise a little patience to get the image steady and in focus; however, once it's set up correctly, you'll get beautiful close-up results.

 Paint it black and no one will know it's cardboard!

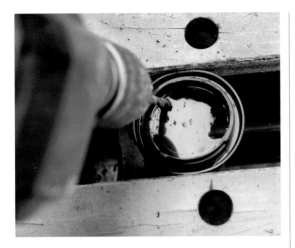

1. Using a drill, remove all the plastic on the body cap that is inside the mounting ring.

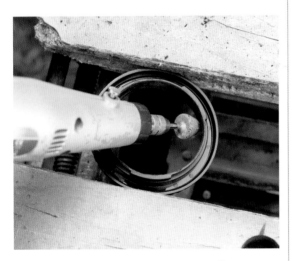

2. Sand the inside of the body cap until it's smooth.

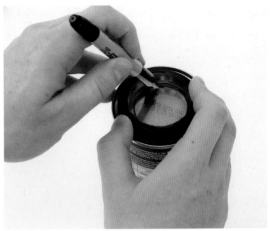

3. Place the body cap on the metal end of the cardboard tube and draw around the circle you cut out.

4. Using the box cutter or another tool, cut the circle you just drew out of the base of the tube.

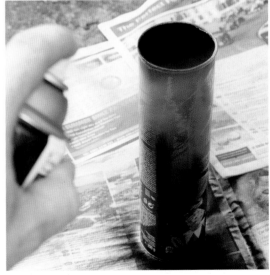

5. Spray paint the cardboard tube black.

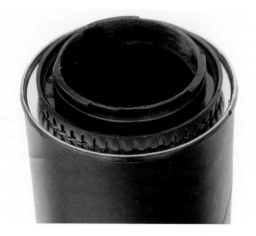

6. Attach the body cap to the tube using the glue gun, aligning it with the hole you cut. Be careful not to get hot glue on your fingers.

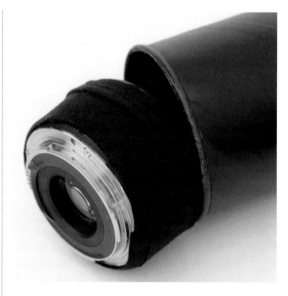

8. Place your lens backwards as shown into the open end of the tube.

7. Wrap the black fabric around your lens until it fits tightly inside the open end of the tube. Secure the fabric with tape.

9. Attach the body of your DSLR to the body cap on the other end of the tube.

10. Focus by changing the distance between the camera and the subject.

11. Set the exposure manually.

Optional: use a tripod to steady the camera for less camera shake and a sharper image.

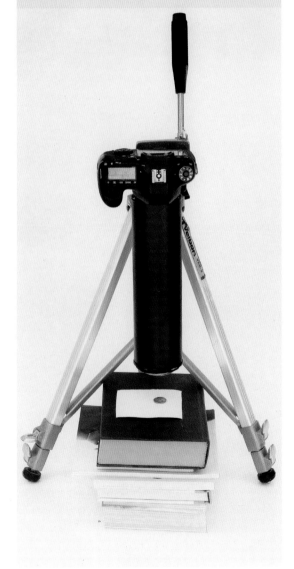

↑ You can capture incredibly close-up images using this homemade extension tube.

SUNPRINT

COST: $$$
DIFFICULTY: ▮▯▯

MATERIALS:
- Objects for your image
- Sunprint paper (provided in the kit)
- Cardboard
- Acrylic sheet (provided in the kit)
- Shallow container full of water
- Paper towel

Sunprint kits are based on the cyanotype process, which means that when the paper is exposed to the sun it will turn blue and any parts that are obscured from the sun will remain white. These kits are available online and come in a variety of sizes. By placing interesting shaped objects onto the paper you can create patterned prints.

The more confident and experimental you get with the process, the more detailed and creative the patterns can become. These prints look particularly good framed and making them can provide hours of fun!

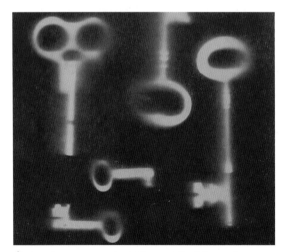

↑ A sunprint image of keys. The blurred edges add a ghostly effect and are caused by the light getting underneath the edges of objects that don't lie perfectly flat.

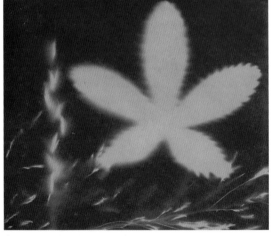

↑ You can make sun prints of plant material, household objects, jewellery, found objects or even transparencies.

1. Choose interestingly shaped objects for your sunprint image.

2. Place the sunprint paper on a piece of cardboard (this will make it easier to move).

3. Arrange your objects on the piece of sunprint paper. The paper begins to expose when it comes into contact with even a little sunlight, so find a spot with no sunlight to do this – for example, a room with the curtains or blinds closed.

4. Place the acrylic sheet on top of the object(s) and your sunprint paper, flattening them together. This will help to make cleaner lines.

5. Place your sunprint outside. If in direct sunlight, the image should take around 5 minutes to fully expose. In cloudy conditions, it could take up to 30 minutes.

6. Check your image. Exposure to sunlight will turn the paper without objects on it almost white, leaving the part that was covered blue. When all the visible paper is nearly white, your sunprint has finished exposing.

7. Remove the acrylic sheet and the object(s) from the sunprint paper.

8. Place the sunprint paper into your container of water and leave it for up to 5 minutes. During this time, the blue will turn white and the white will turn blue.

9. Place your sunprint paper on an absorbent surface, for example a paper towel, and allow it to dry.

35MM DISPOSABLE CAMERAS

Disposable cameras have an instant charm. They evoke memories of taking photos in years gone by, snapping at candid scenes and the magic of waiting for the film to be developed. Open many an old family album and you're likely to find memories in the form of yellowing pictures taken with disposable cameras.

The photos from disposable cameras are often grainy, sometimes out of focus and often with less-than-perfect exposure, however this all adds to the vintage feel of the images. Bringing a 35mm disposable camera on a shoot and taking photos with both your digital camera and the disposable camera can provide a different take on the same image.

COST: $$$
DIFFICULTY: ▪▫▫

MATERIALS:
- 35mm disposable camera

1. Purchase a disposable camera.

2. Experiment by taking photos with and without flash.

3. Take your photos to be developed.

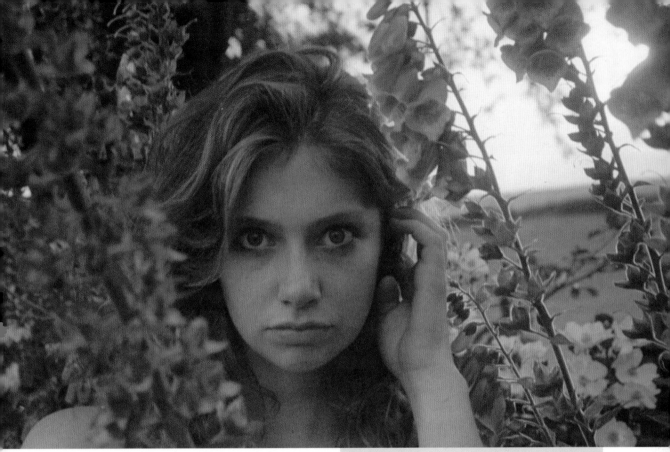

↑ This scene, captured with the plastic lens of a disposable camera, calls to mind memories of summer afternoons.

When getting the film developed, ask for digital versions of the photos to be put on a disk or sent to you so you can edit them and post your images online.

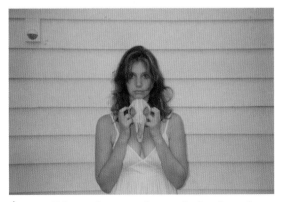

↑ An off-beat glamour shot with the digital camera becomes a silly contextual snapshot thanks to the disposable's simple metering.

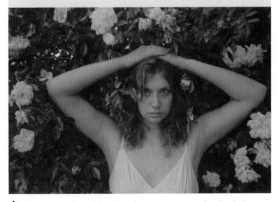

↑ Too much white in these scenes fooled the disposable camera into underexposing, but it's all part of the charm!

EXPERIMENTAL FILM

Shooting with experimental film is a creative way to add a new look to your photography. Several companies including Revolog and LomoChrome have started to modify film or sell expired film that exhibit spots or washes of colour and patterns over your images. Different film can be used to create various effects, so whether you are looking for a coloured filter, vintage crackle or bright sparks and patterns, there are plenty of options to add fun elements to your photography.

Although these effects can be added in photoshop, there is a magic and excitement in using film. Waiting for the photographs to be developed adds an element of the unknown, and the unexpected results can provide further inspiration.

COST: $$$
DIFFICULTY: ▉☐☐

MATERIALS:

- 35mm film camera
- Experimental film such as Revolog or LomoChrome Purple 35mm film

1. Purchase some experimental film.

2. Place the film in your camera.

3. You can head out on planned shoots or have the camera handy to take candid photographs and shoot locations around you.

4. Take the film in to be developed and wait to see your results!

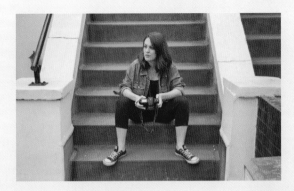

← A blue wash appears over the image creating a melancholy feel, adding emotion to the distant gaze from the model.

↓ The colours in this photo look slightly faded creating a vintage effect.

↑ The blue-green hue adds a dreamy feel.

→ The bright red on the building contrasts with the sky to create a surreal effect.

Other brands that sell experimental film include Lomography, KONOS and Kodak Portra. Companies often provide example photos showcasing the colours and patterns that can be created. If you are delving into the world of experimental film for the first time, do some research to help you choose your desired effect.

VINTAGE LENSES

The type of lens you use can entirely change the result you get in your image and therefore it is no surprise that there are such a wide range of lenses available on the market, each producing different effects. It is useful to have a variety of lenses in your kit so you can choose the best way to take strong portrait, landscape, macro or wildlife photographs, to name a few. However, building a collection of new lenses can be very expensive. Experimenting with vintage lenses helps you achieve different and beautiful effects and also saves money.

COST: $$$
DIFFICULTY: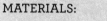

MATERIALS:

- 35mm film camera
- Adapter if needed
- Vintage lens (available from websites such as eBay and Etsy)

1. Attach the lens adapter to your camera if necessary to pair the two together.

2. Attach the vintage lens.

3. The camera will not autofocus with the vintage lens, so you will need to focus manually and set the f-stop manually.

Some vintage lenses can fit your camera without an adapter.

USING DIFFERENT LENSES

Many companies now manufacture lens adapters that fit onto your DSLR or SLR camera and allow you to affix a vintage lens onto the body. These adaptors can be purchased very cheaply and can be used for a variety of different lenses.

Some vintage lenses will provide exactly the same results as the newest models but are much cheaper. It is important to remember that you will need to manually focus with a vintage lens and therefore it may require a bit more patience on a shoot.

Other vintage lenses will create drastically different results from the current models. For example, we chose an old HELIOS-44-2 58mm f/2 M42 lens for the image below, as it creates a swirly bokeh and were really happy with the results it gave. It's worth researching the effects lenses might cause before purchasing. However, it can also be incredibly inspiring to experiment with a new lens and see what results you can create!

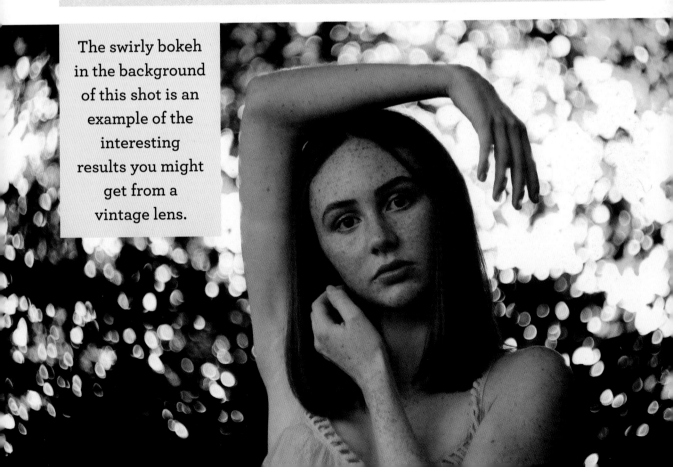

The swirly bokeh in the background of this shot is an example of the interesting results you might get from a vintage lens.

STUDIO SETUPS

OUTDOOR STUDIO

Studios provide a great way to get a clean, even background in order to let you and the viewer focus on the subject you're working with. However, if you like working with natural light, a conventional studio setting can be off-putting. With this hack, you can turn your garden or any outdoor space you have permission to use into a studio simply by using a large sheet of plain paper in a colour of your choice and a studio background stand. Making your own outdoor studio means you can get the best of both worlds – a great space to shoot with your model and all the benefits of natural light.

COST: $$$
DIFFICULTY:

MATERIALS:

- Studio background stand
- Large roll of plain paper
- 2 rocks, bricks or other heavy objects
- Tripod

Outdoor studio shooting on this day was ideal thanks to the even, overcast sky.

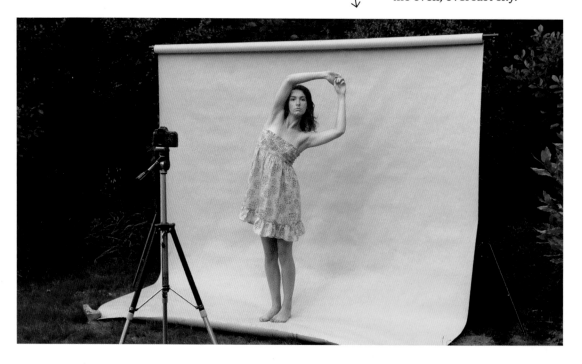

Overcast light is cool (bluish). For a warmer light, try shooting during the golden hour on a sunny day.

1. Attach the roll of paper to the studio background stand.

2. Place the studio background in a clear area.

3. Roll down the paper so that it extends onto the ground to make a base for the model to stand on.

4. Secure the paper in each corner with heavy objects such as rocks or bricks.

5. Place your camera on a tripod in front of the background.

6. In post-production, crop the image so the surrounding outdoor area cannot be seen.

↑ Clean background created by the paper backdrop

EASY HOME STUDIO

When working with a model, an indoor studio provides a controlled environment in which to work. It is an excellent setting for fashion-style shoots or for beautiful portraiture and headshots. However, hiring a studio can be expensive. With this hack, you can turn any room in your house into a home studio with a large roll of paper, tape and some bulldog clips. If you have studio lights, you can set these up at home. Otherwise, simply set up your at-home studio near a large window or glass door and shoot using natural lighting, with the aid of a reflector (see pages 18–19).

COST: $$$
DIFFICULTY: ▮▮▯

MATERIALS:
- Large roll of paper in a plain colour such as white or grey
- Strong sticky tape
- Bulldog clips
- Tripod or studio background stand (optional)

DIY home studio using a studio background stand. The roll of paper is a cheaper alternative to pre-made fabric backgrounds.

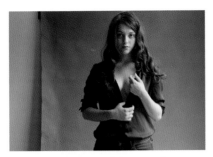

↑ Behind the scenes of the DIY home studio. A large roll of grey paper is stuck to a wall using strong sticky tape.

→ The cropped image shows the effective use of the DIY studio background. Light from the window at the side creates soft brightness and shade across the model's face and the grey background.

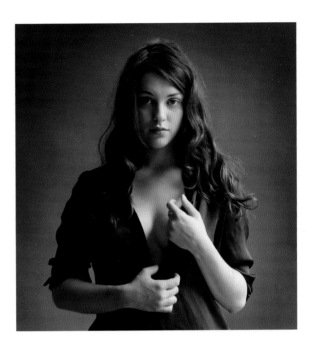

1. Locate a wall or flat surface next to a window or glass door in your room and clear the area.

2. Roll out a large sheet of thick paper in a plain colour such as white or grey.

3. Using strong sticky tape or bulldog clips, affix your paper to the wall or flat surface, or if you have a tall tripod or background stand, attach the paper to it. This will make your background portable.

5. Sit or stand your model in front of the background. The model will be lit by the natural light from the window to the side.

6. Alternatively, if using artificial lighting, set up your equipment so that the subject is illuminated.

7. If needed, prop a reflector against a chair or upright surface opposite the window so that it is facing the model. This will balance the natural light that is coming in from the opposite side.

VIBRANT PAPER BACKGROUNDS

COST: $$$

DIFFICULTY: ■□□

MATERIALS:

- Patterned or brightly coloured wallpaper or large sheets of paper
- Strong sticky tape
- Scissors

White and grey backgrounds allow the subject to pop out of the image, but patterned backgrounds can inject colour into your image. A colourful background can also suggest different locations and times to the viewer. This hack shows you how to use coloured and patterned paper for fun backgrounds that you can use to create visually appealing product photos. This works effectively indoors and outdoors and with natural or artificial light.

↓ The pastel patterns make a vibrant background for the vintage props.

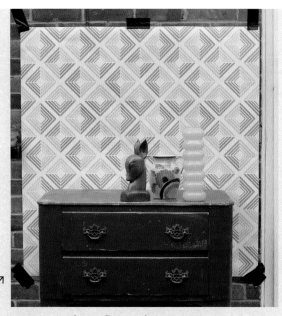

Paper taped to a flat surface

THINK OUTSIDE THE BACKGROUND

Don't be afraid to experiment with different types of paper – vintage wrapping paper or wallpaper can create effective backgrounds. You can also try newspaper and maps. Let your imagination run free and try a variety of colours and patterns for striking and artistic shots.

↓ This designer wrapping paper made a perfect mid-century background for photographing vintage items.

1. Cut your wallpaper or large sheet of paper to size. You will need at least a few inches around the sides of the objects.

2. Secure the paper to a firm surface such as a wall or a fence.

3. Place your objects in front of the paper.

BEDSHEET BACKGROUNDS

COST: $$$

DIFFICULTY: ▮▯▯

MATERIALS:
- Bedsheet or fabric
- Strong tape or bulldog clips

Studio backgrounds are useful additions to your photographic kit. Whether shooting portraits or showcasing objects, a background can help you to create a striking image. However, backgrounds can be pricey.

This hack shows you how to make a large piece of second-hand fabric into a fantastic photo background.

1. Purchase a good-sized piece of fabric at a boot fair. You will need enough fabric to fully surround the subject of your image, as in the photo opposite.

2. Attach the fabric to a sturdy wall or surface using strong tape or bulldog clips.

3. Place your subject in front of the fabric.

4. It is a good idea to create an element of colour matching in the image, for example when working with a model, match a colour from the background to their clothing or makeup.

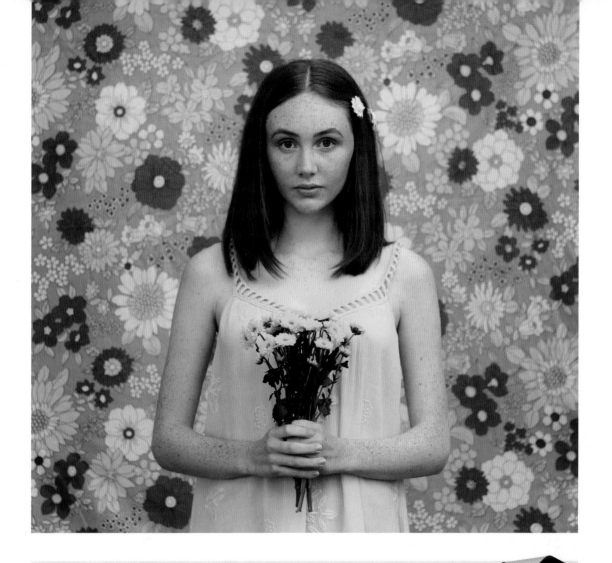

BACKGROUNDS ON A BUDGET

Boot fairs are a great place to purchase props and outfits for photoshoots at a low price. If you're looking for a classic studio background, search out a plain coloured fabric in white or grey. You can also look for coloured and patterned backgrounds to create playful effects.

WORKING WITH MODELS

CHEAP BUT AMAZING PROPS

COST: $$$
DIFFICULTY:

MATERIALS:
- Model
- Variety of interesting objects you have found at home, in boot fairs or charity shops

When photographing people, the subject is often the focal point of the image; however, props can be a creative way to add further interest to create visual curiosity or provide context. Props can be placed in the background or foreground of an image or given to the model to interact with while you shoot. The decisions you make will change the way a viewer interacts with the image. For example, you could photograph a model leaning on a wall and looking out to sea. If you ask the model to hold a camera, it affects the way that the image is perceived – they are no longer wistfully staring outward, but looking for an image themselves.

It can feel as though you need to invest lots of money in seeking out and buying props, but you can find cheap and effective ones at little or no cost. Consider the story your own belongings could tell. Alternatively, head out to a boot fair or garage sale and look for items that you find unusual or visually appealing. You can also ask the model to bring something to a shoot that is meaningful to them.

↓ We bought this bright, fur-trimmed jacket cheaply from a closing-down sale.

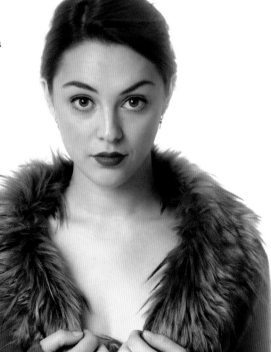

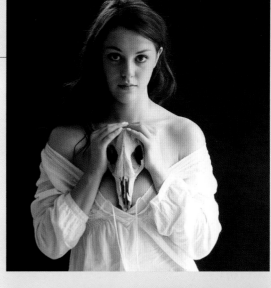

→ A skull, bought at a boot fair, adds curiosity to the photograph.

1. Collect your props. Scour your home for interesting items, or visit a boot fair or garage sale and haggle to get a great deal on someone else's once-loved item.

2. Pack a variety of props in your photographic toolkit. Consider a story you wish to tell before heading out on your shoot, or try asking the model to hold or interact with a prop to get a different take on the image you've just captured.

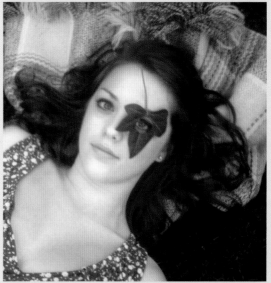

→ A hole was cut out of a leaf found on the ground, creating a surreal feel to the image.

Sometimes a prop's main purpose can be to balance or complement the scene. The orange blanket here serves as a garment, but what it does best is contrast the turquoise wall in the background.

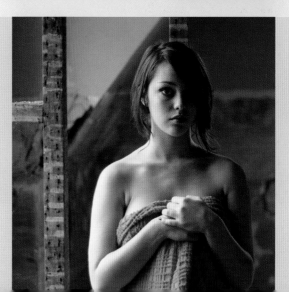

NO-COST LOCATIONS

COST: $$$
DIFFICULTY: ◼◻◻

There can be an expectation that great photos need to be taken in a studio or a dramatic and beautiful landscape, but the truth is that strong photographs can be taken in any setting accessible to you. If you are interested in creating studio photographs, you've seen how you can create your own budget studio in your home simply by setting up a plain background and using lighting you already own or making the most of natural light through a window or glass door (see pages 124–125). You can also make use of your home, garden, public spaces (see pages 50–53) or ask to use a friend's space for a huge variety of no-cost backgrounds and settings.

1. Identify some no-cost locations, such as your home, garden, shed, a friend's house, local woodland or parks, streets, and so on. If using a friend's outdoor or indoor space, make sure you ask permission!

2. Plan the kind of emotion and shots you would like to create. Making an 'ideas' book digitally or on paper can help with putting together a theme. Try to find images taken in similar locations to inspire you on the shoot.

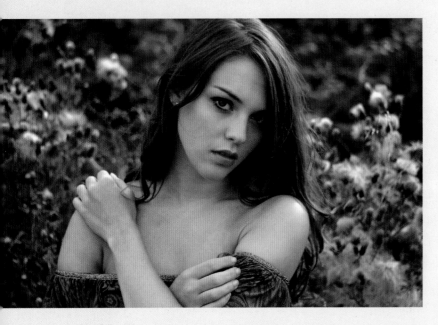

← Wildflowers in a local park create a natural look.

Finding a no-cost location can require some planning. You will need to think about the feeling you want to create. Often, using your own home can provide a relaxed feel. Research similar images to get ideas for the kinds of shots you can create. Using greenery in the background of a shot taken in a garden, park or woodland creates a natural, outdoor feel. Visit the locations you want to use and experiment with shooting at different times of day using natural light. If shooting a landscape or subject outdoors, remember that the golden hour (see pages 90–91) is a wonderful time to get beautifully lit photographs.

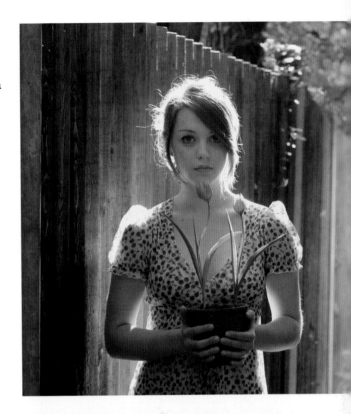

→ The fence of an alleyway is used to add a leading line and channel the natural light.

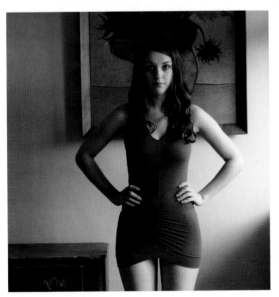

↑ Colour matching achieved at home.

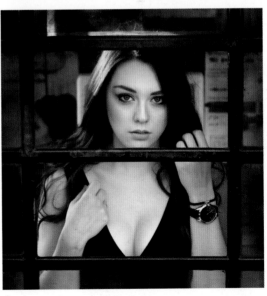

↑ Phone boxes can create a strong narrative and provide frames within your photographs.

GET TO THE BEACH

The beach has long been an escape and a place where people can go to think, reflect, relax and play. It can evoke memories of childhood games in the sand, romantic walks and sunset evenings with friends. The emotive quality of the location therefore makes it a perfect setting that will spark stories from the viewer. Beyond this, the beautiful landscapes carved out by the waves make for striking lines in nature photography and in backgrounds when working with models. The surroundings create potential for powerful shots with huge natural structures and stunning horizon lines. If you're working with a model, the sand and sea are wonderful natural reflectors, flooding your subject with beautiful light.

COST: $$$
DIFFICULTY: ▮▯▯

MATERIALS:
- Access to a beach
- Model
- Reflector (optional – see pages 18–19)

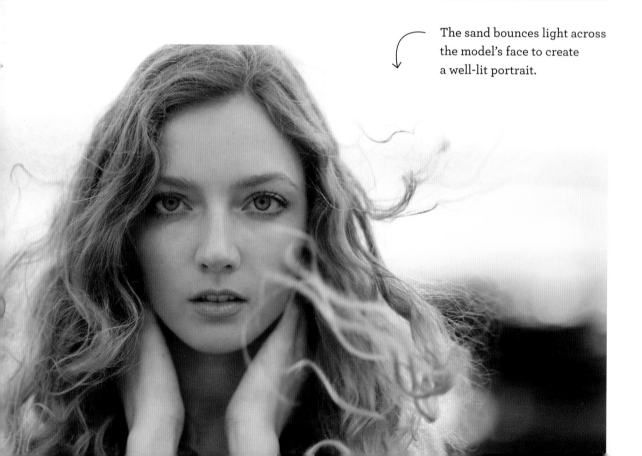

The sand bounces light across the model's face to create a well-lit portrait.

The man-made architecture around the beach can be an excellent backdrop too. Beach huts, stairs or benches can create leading lines or add colour. Industrial structures like piers can also be striking visual elements.

When working in any natural setting there are difficulties, and the beach is no different.

It can be windy, and weather tends to be more extreme, so prepare for the cold or heat. Bright sunlight can also present challenges, but you can make shade or balance light easily using a reflector. In addition, always watch out for the horizon line and make sure it's straight, as it will be difficult to correct in post production.

EXPLORING THE POSSIBILITIES

The photos here provide ideas for taking great shots on the beach. Let your creativity run wild and explore the wealth of beautiful shots that can be taken by the sea.

↓ Frame the model with landscape elements such as cliffs or rocks to draw the viewer's eye to the subject. Unusual beach attire can also spark interest, along with some subtle coordination of colours, like we've done below (see pages 84–85).

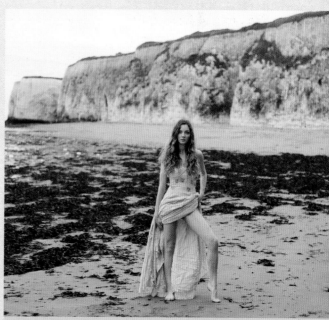

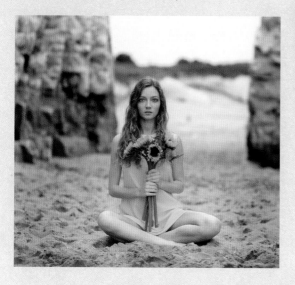

The expansive surroundings of the beach make for a dramatic image, and if you go during typical down times, you'll have the place to yourself.

PERFECT POSES

When working with a model, often one of the most challenging aspects is capturing strong poses that add to the photo and look natural. Although the focus of the shot is often the model's face, it is important to think about how you are incorporating the arms, the legs and the rest of the body, and what story this tells in your photograph. It is often all too easy to get stuck in a routine of using the same poses that create similar results again and again. To help spark new ideas, research poses that you like or take along a paper or digital 'ideas' book when you go on a shoot. The next few pages feature a collection of images that you can refer to and show the model you are working with when you need inspiration for poses mid-shoot.

This hack helps you to create your own ideas book and it presents our top ten full-length poses and our favorite portrait poses to get you started.

COST: $$$
DIFFICULTY: ▮▮▯

MATERIALS:
- A model
- an ideas book (optional)

↓ Direct the model to move around, and shoot as they do so. This gives you the chance to capture variations that look more natural.

When directing a model, try to describe the position you want but also don't be afraid of demonstrating yourself. This is often a far quicker and more effective way for the model to visualise the pose and recreate it.

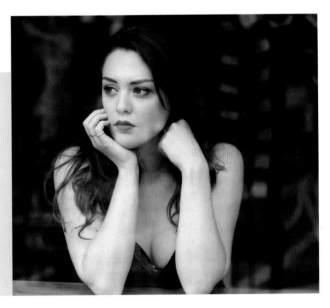

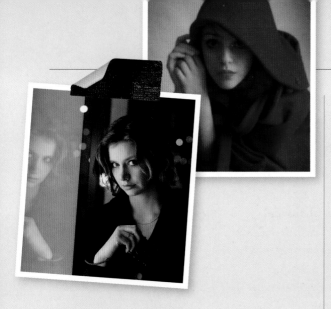

Method

1. Choose the location for your model.

2. If you have an ideas book, show the model the image you are trying to create.

3. Be clear about your instructions if you want your model to modify a pose – remember that your right is their left!

4. It's useful to demonstrate positioning as it will help the model to get into position quicker.

5. Take a look at the whole pose. Check that you are happy with the positioning of arms, legs, head and body, and that it works with the background.

Creating your ideas book

1. Do some research – look out for portrait photos that you find beautiful or intriguing.

2. Collect your images – tear pages out of magazines, take photos of portraits from books, save images you find online. It is also helpful to revisit any of your own photos to review any poses you think work or don't work.

3. Compile your images by sticking them into a scrapbook or storing them in a digital album on your phone or online.

4. Remember to bring your ideas book with you on a shoot, or make sure you can access your digital album on a tablet or phone.

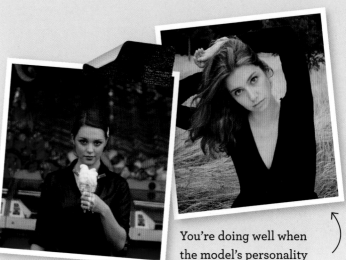

You're doing well when the model's personality is shining through.

10 FABULOUS FULL-LENGTH POSES

Consider what you are trying to capture and how the model's body language can help to portray this. When a model is facing the camera, with their body open to the viewer, it can convey a welcoming, comfortable feel to the image.

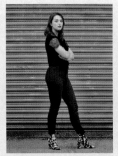
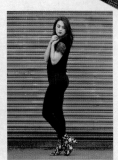

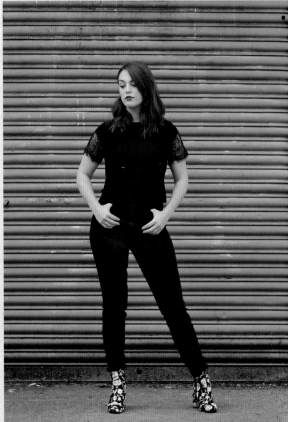

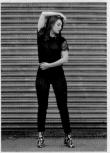

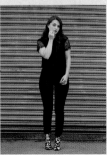

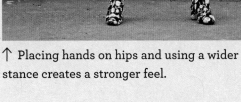

↑ Placing hands on hips and using a wider stance creates a stronger feel.

Turning away from the camera or covering the body with the arms or legs creates a more vulnerable pose. When shooting portraits, consider including the hands. Often, hands placed gently against the face or hair can add more interest to the shot.

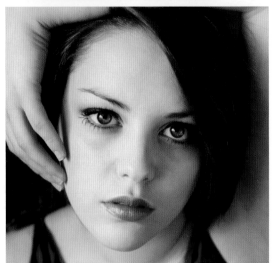

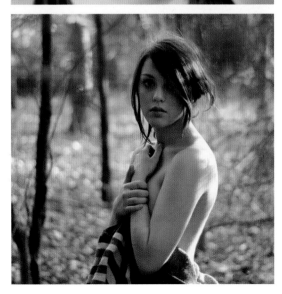

Index

B

backgrounds 10–11, 24–25, 36–37, 40–41, 58–59, 84–85, 122–123, 124–125, 126–127, 128–129, 134–135
beach 136–137
bean bags 42–43
beauty dish 32–33
black and white 11, 78–81, 93
blur 12–13, 76–77

C

camera shake/ movement 42–43, 44–45
close-up (see also *macro*) 60–61
colour
 backgrounds 126–129
 coordinating 84–85
 filters 16–17, 34–35
 light 30–31, 62–69

D

details 106–107
diffusers 14, 26–29
disposable cameras 94, 114–115

E

experimental film 116–117
experimentation 13, 17, 30–31, 35, 49, 54, 61, 63, 69, 71, 76, 78, 81, 86, 89, 101, 102, 112, 116–117, 118–119, 127, 129

F

filter-like effects 16–17, 34–35, 48, 102–105, 116
flash 14–15, 32–33
foreground 82–83
framing 60–61, 63, 82–83, 88–89, 105, 135, 137
freelensing 76–77

G

golden hour 56, 90–91, 123, 135

I

inspiration 52, 116, 119, 134

L

leading the eye 82, 135, 137
lens accessories 22–23, 108–111
lens hood 22–23
light box 10–11, 24–25
light panel 30–31
light/lighting 10–11, 14–15, 18–19, 20–21, 24–25, 26–29, 30–31, 32–33, 40–41, 54–57, 90–91, 122–123, 124–125, 135, 136–137

locations 38, 42, 50–51, 84–85, 90–91, 134–135, 136–137, 139
low light 30, 40

M

macro 106–107, 108–111
mirrors 88–89

N

negative space 86–87

P

panning 45
photo challenge 94–95
pinhole 98–101
planning 50–53, 84–85, 90–91, 134–135
polyptychs 30, 34, 92–93
posing 60, 138–141
positive space 86–87
post-production 17, 21, 35, 60–61, 65, 71, 81, 102, 104, 123
props 71, 84, 85, 126, 129, 133–134

R

rain cover 38–39
reflections 88–89
reflectors 14–15, 18–19, 20–21, 30, 40–41, 124, 125, 136–137
Rule of Thirds 70–71, 87

S

sharpness 42–43, 44–5, 77, 106
shutter speed 42, 101
soft focus 12–13
studio 120–9
sunprints 112–113

T

tripod 38, 42, 44, 45, 111

V

viewfinder 102–105
vintage
 effect 12, 48, 98, 102, 102–105, 114, 116, 127
 equipment 118–119
visual appeal 78, 126

W

weather 38–39

Picture credits

About the authors & Acknowledgements

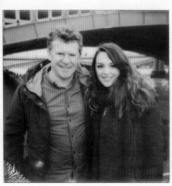

Imogen Dyer has used her passion for education and the arts to co-found Weekly Imogen, the hugely popular photography YouTube channel where she presents informative and entertaining videos.

Mark Wilkinson is a fine-art specialist and passionate photographer. He delights in taking portraits in simple settings and extracting every last ounce of colour, texture and, crucially, natural light.

We would like to extend a huge thank you to the team at Ilex who have shown so much support and matched our photographic enthusiasm!

Thank you to Jonathan Crew for his wonderful polaroid of us and to Emma, Caitlin, Maria, Amelia and Holly for their beautiful modelling and photography – all of which feature in this book.

Endless gratitude also goes out to all of our viewers and followers who have supported our work. It is so wonderful to be part of so many people's photographic journeys and we are constantly inspired by your stories and photos.

Mark would particularly like to thank Sara and his two children Adam and Holly for their never-ending support. He would also like to extend his gratitude to Imogen for sticking with him over the years and for being so 'in-sync' with the way he works.

Imogen would particularly like to thank Mark for his endless inspiration and enthusiasm. She would also like to extend a huge thank you to her partner, David, who has been a sounding board, all-round good egg and constant source of support throughout her creative endeavours.